Moon by the Window

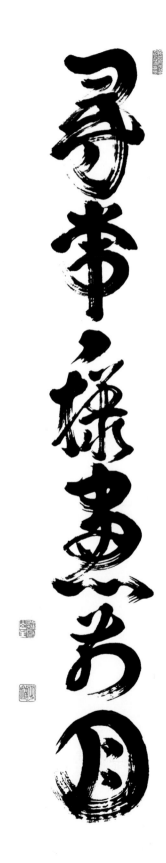

Moon by the Window
The Calligraphy and Zen Insights of Shodo Harada

translated by Priscilla Daichi Storandt

edited by Tim Jundo Williams and Jane Shotaku Lago

WISDOM PUBLICATIONS • BOSTON

Wisdom Publications
199 Elm Street
Somerville MA 02144 USA
www.wisdompubs.org

Red Pine (translator), poems 1 and 3–5 from *The Collected
Songs of Cold Mountain, Revised and Expanded Edition*,
copyright © 2000 by Bill Porter, reprinted with the permis-
sion of Copper Canyon Press, www.coppercanyonpress.org.

Cover design by Phil Pascuzzo.
Interior design by Gopa & Ted2, Inc.
Set in Sabon 10.6/15.5.

Wisdom Publications' books are printed on acid-free paper
and meet the guidelines for permanence and durability of the
Production Guidelines for Book Longevity of the Council on
Library Resources.

*Library of Congress
Cataloging-in-Publication Data*

Harada, Shodo, 1940– artist, writer of added
commentary.
 Moon by the Window : Zen Insights of Shodo
Harada / translated by Priscilla Daichi Storandt ;
edited by Tim Jundo Williams and Jane Shotaku
Lago.
 pages cm
 Includes index.
 ISBN 0-86171-648-5 (pbk. : alk. paper)
 1. Harada, Shodo, 1940– 2. Zen calligraphy—
Japan. 3. Zen poetry, Japanese—Translations into
English. 4. Zen Buddhism. I. Storandt, Priscilla
Daichi, translator. II. Williams, Tim Jundo, editor.
III. Lago, Jane (Jane Shotaku) editor. IV. Title.
 NK3637.H37A4 2011
 294.3'4432—dc22

 2010052129

ISBN 978-0-86171-648-7
eBook ISBN 978-0-86171-634-0

Printed in China.

15 14 13 12 11
5 4 3 2 1

Contents

Preface

References to the moon appear frequently in Zen koans as a shorthand for the awakened mind. Although these calligraphy phrases are not the moon itself, they offer a means for awakening to the mind's wisdom by serving as a reminder of the teachings when a teacher is not present. The calligraphies themselves provide an expression of the awakened mind, a visual Dharma, capturing the living energy of a moment in ink on paper. Thus, words and images work together to convey the essence of Zen to the viewer and reader.

Known internationally as a calligrapher and master teacher, Shodo Harada was born in 1940 in Nara, Japan. He began his Zen training in 1962 when he entered Shofuku-ji monastery in Kobe, Japan. After training under Yamada Mumon Roshi (1900–1988) for twenty years, he received Dharma transmission and was appointed abbot of Sogen-ji monastery in Okayama, Japan, where he has taught since 1982.

Harada Roshi is heir to the teachings of Rinzai Zen Buddhism as passed down in Japan through Master Hakuin and his successors. Harada Roshi's teaching includes traditional Rinzai practices informed by deep compassion and permeated by the simple and direct Mahayana doctrine that all beings are endowed with the clear, pure Original Buddha Mind. Proceeding from this all-embracing view, Harada Roshi has welcomed serious students (women and men, lay and ordained) from all over the world to train at Sogen-ji and the temples he has established near Seattle, Washington, and in Germany, as well as at more than a dozen sitting groups around the world.

This book began as a series of hand-bound gift books from Shodo Harada to his students. Each calligraphy was individually inked on a sheet of paper around five feet in length. They were then photographed by Alan Gensho Florence and Sabine ShoE Huskamp and prepared for printing by Alan Gensho Florence. The text to accompany each calligraphy was translated by Priscilla Daichi Storandt and then edited for the hand-bound books and reedited for inclusion here. For this book, Thomas Yūhō Kirchner and Mitra Bishop reviewed the text and offered much appreciated suggestions and corrections.

Tim Jundo Williams | Jane Shotaku Lago

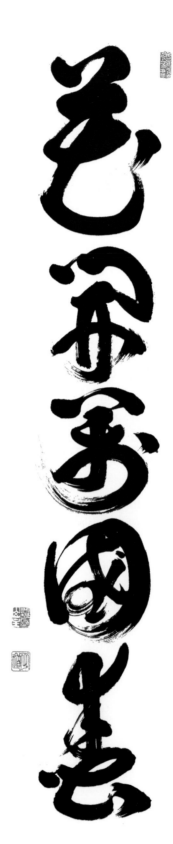

花開萬國春

Hana wa hiraku bankoku no haru
A single flower blooms and throughout the world it's spring

In Zen, the word *flower* often refers to the Buddha, who is said to have been born under flowers, to have become enlightened under flowers, to have transmitted the Dharma with a flower, and to have passed away under flowers.

When the Buddha was enlightened under the bodhi tree, he saw the morning star and exclaimed, "How wondrous! How wondrous! All beings from the origin are endowed with this same bright clear Mind to which I have just awakened!" For forty-nine years the Buddha taught that each and every person has the possibility of awakening and that this opportunity to awaken is the deepest value of being alive.

One day on Vulture Peak, instead of lecturing as usual, he silently held out a single flower, and Makakashō Sonja smiled spontaneously. With this the transmission of the Dharma began.

The Buddha knew that his awakening was the awakening of all people and that no fame or fortune or any possession or knowledge brings a joy as great as the joy of awakening to our deepest Mind. We too can be born and can die under flowers, can finish this life as the Buddha did.

When a single flower blooms, it is spring throughout the world.

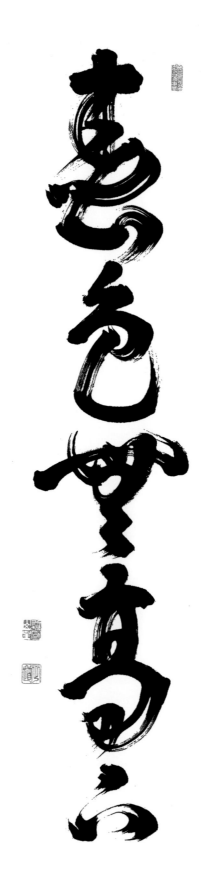

春色無高下
花枝自短長 *(overleaf)*

Shunshoku ni kōge naku
Kashi onozukara tanchō

In spring colors there is no high nor low
Some flowering branches are by nature long, some short

In spring, the ice melts and the severe chill of winter loosens its grip. In the warm sunlight, blossoms appear—plum, peach, apricot, and many others. Everywhere, signs of spring are evident. The insects start to fly, seeking the sweetness of the flowers, and the birds sing. Everything that has endured the hard winter all at once expresses the great joy of this season.

This is the Way of Great Nature, the "sutra" that embraces all and through which we receive everything. Yet each of us carries a multitude of memories and knowledge, dualistic perceptions and strivings that influence our outward perception and distort our view of Nature. We can describe and attempt to explain this Great Nature, but to receive it directly and without hindrances is difficult.

When we let go of extraneous thoughts and see each thing exactly as is, with no stain of mental understanding and dualism, everything we see is true and new and beautiful. For those who have awakened to this Truth, whatever they encounter is the Buddhadharma, just as it is. No matter what is encountered, there is nothing that is not the Truth. When we look at something and don't recognize it as the Truth, that is not the fault of the thing we are seeing; it is because our vision is obscured by explanations and discursive thoughts.

Doing zazen, we let go of all extra thinking and perceive with a simple, direct awareness. There is no longer any separation between the person who is seeing and what is being seen. No explanations or ideas about what is being seen are necessary. Not holding on to any preconceived idea, we match perfectly with what we see, and there the Truth and the world are brought forth spontaneously. If we have no subjective opinions or preconceived notions, no small-minded "I" remains. There is only oneness. Anything we see and hear is Truth. There is nothing that is not the Buddha.

From the origin we have a mind like a clear mirror. To know this mind directly and

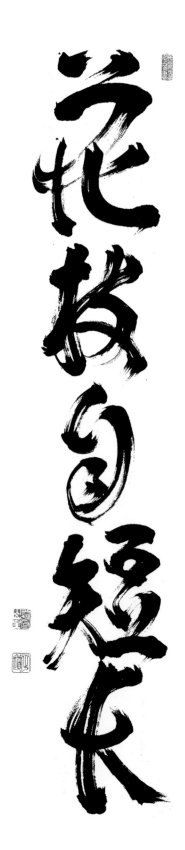

花枝自短長

completely is satori. That empty mirror gives rise to many associations as it encounters the outside world. When we become that emptiness completely, the world is born forth, clear and empty. Then, whatever we encounter, we become it completely and directly. This is the subtle flavor of zazen and is the mind of Buddha and of God.

When we see things from this mind, we see that the southern branch of the tree is longer than the northern branch, although the same warmth of spring touches both. Long is not absolute, and short is not lacking in anything. We need to see everything in society in that way as well. When we are with an elderly person we become that elderly person and can say, "Yes, it must be so lonely, so hard." When a child comes, we are able naturally to sing and play with the child in the child's way. We see a pine and become a pine; we see a flower and become a flower. This is our simple, plain, natural mind. From there we have the purest way of seeing, and this is where the Buddhadharma lives.

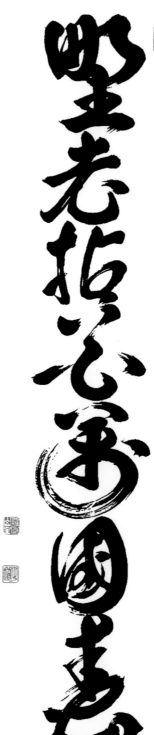

聖老指心家國畫

野老拈花萬國春

Yarō hana o nenzu bankoku no haru

An old peasant plucks a flower—spring in myriad lands

This phrase is found in the *Record of Rinzai:* "The green of the winter pines endures a thousand years. An old peasant plucks a flower—spring in myriad lands."

The quiet mind of such a person is like spring, and this is the state of mind everyone wants to know. To practice Buddhism is to trust and believe in people. In old age and eternal life we show respect, not hurrying without needing to. If we are pure and clear in our thoughts and actions, our life will be that of a person of true virtue and deep character. We will become brighter and more open, and our power of the Path will be clearer and clearer as we are no longer moved around by anything. Here there is long life, beauty, energy, and joy.

If we hold on to nothing at all, and are not moved around by anything, then we will see that this very body is the body of the Buddha, and there spring is found throughout the world.

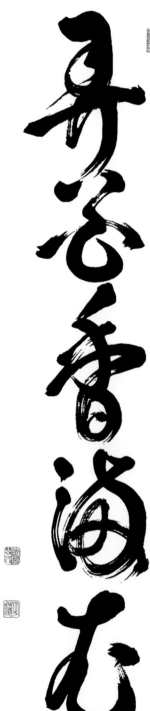

身花香海光

弄花香満衣

Hana o rō sureba, kō e ni mitsu

I play with flowers and their fragrance clings to my clothes

This line, from the records of Master Kidō, is a couplet with "I scoop up water and the moon is in my hands."

Great works of music and art naturally guide people to the religious. Such works do not come from another realm; those who create them cannot make things that are apart from their minds. But neither do such works come from the disorder of the ordinary world. That which has been expressed from humans' highest state of mind conveys the profoundest truth. This truth gives birth to a peace that is beyond all conflict and friction, a peace not found in the day-to-day world of people. It is a splendid, clear, and pure state, and we cannot help but honor it with the deepest respect. It is this high level of human character that is called *Buddha*.

All beings, all of the Buddhas and Ancestors, are unified in this Great Mind, as is all time, past, future, and present. We are one with the great joy of the abundant Dharma and know the samadhi of delightful play beyond time and space. There is no joy beyond this endless Dharma joy, and this realm is what forgives everything.

After living for only a few days, a flower dies, showing the transience of life. Yet in this flower we find eternal joy and the life of the Buddha as well. This flower, whose fragrance scents our garments when we toy with it, is this abundant Mind.

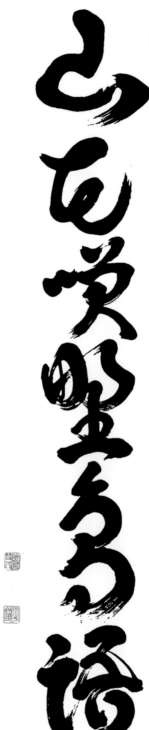

山花咲野鳥語

Sanka warai yachō kataru
Mountain flowers bloom, wild birds sing

Becoming the flowers, we bloom; becoming the birds, we sing. We lose track of whether we are the bird or the bird is us; all distinctions drop away. When our mind opens completely and we pierce through the bottom of the ego, there is nothing throughout the heavens and the earth that we need to seek. This body, as it is, is the Buddha. When we can receive this, the scenery of spring is more than just the forms of nature. When the Buddha saw the morning star he was awakened to his clear Original Nature. Kyōgen was enlightened upon hearing a piece of rubble hit a stalk of bamboo, and Hakuin upon hearing the sound of the morning bell. These are all everyday moments. In the midst of our ordinary lives, who knows when or where we will encounter the great radiance of Buddha Nature? Sweeping the garden we ask, "What is this?" Eating our food we ask, "What is this?" Prostrating to everything we ask, "What is this?" This is our living, vivid energy. We creatively continue without letting go, and we don't know what it will be that will bring this great sudden amazement and wonder.

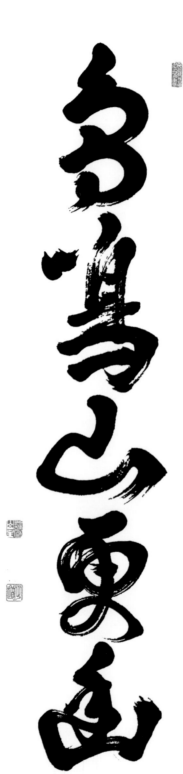

鳥鳴山更幽

This line forms a couplet with "The wind stops, but the flowers still fall." Immediately following a huge gust of wind, the branches and trees and flowers that had been blown about are again still, and in that stillness the birds become quiet and the falling of the flower blossoms can be heard and felt even more clearly. The quiet in the mountains is beyond the imagination of one who lives in the city. This silence goes to the most profound depths of our heart. This serenity is broken by the calling of one bird, and in the ensuing stillness we feel an even greater serenity. Each and every person is born with this perfection, but it is not something we can understand by thinking about it. When conceptual thinking falls away and we are no longer moved around by the winds of words and opinions, we know the depths of this true serenity.

好随芳草去又逐落花回

曹宝麟道生书

始随芳草去
又逐落花回

Hajime wa hōsō ni shitagatte sari
Mata rakka o ōte kaeru

First, I went following the fragrant grasses
Now I return chasing falling leaves

These lines are from the thirty-sixth case of the *Blue Cliff Record*.

One day the priest Chōsha Keijin went for a long walk in the mountains. When he returned to the monastery, the head monk was waiting for him. The monk asked, "Master, where have you been? There are many disciples gathered here for training—what are you doing, just wandering around?"

Chōsha responded, "I went to the mountain to play a little. The cherry and the peach flowers were so beautiful, and while I was looking at them they pulled me right into the deep mountains, and then the clover and the dandelions were blooming and the butterflies were dancing, and while looking at them, I arrived home again." He was saying that the meaning of life is found in the encounters of each and every moment. Although we need to have goals, if we aren't acting playfully within each and every second of realizing our goals—if we think, while in the midst of living and struggling, that we have to wait until later to play—then we aren't realizing the true value of life.

People who work from Monday to Friday often think they have to wait until the weekend to be happy. After five days of suffering through our work, we try to make up for that with two days of being happy—what kind of life is this? The samadhi of the Buddha isn't about waiting for the future but about finding joy no matter where we are, no matter how difficult or miserable our circumstances. It is about living wholly and totally in each instant.

Our lives cannot be lived in a vague way. We have to keep our sight on each footstep and live fully and thoroughly in each second. Life isn't about enduring pain every day and looking forward to something else that will come along later and far away. When each and every moment is true, when our goal is to have a deep worth, to be complete, then in each and every moment we will find deep wonder and amazement and joy, and the value of life will be clear. We must hold this kind of life precious.

舊竹生新篁

舊竹生新筍

Kyūchiku shinjun o shōzu
Old bamboo produces new shoots

These words, from the teachings of Daitō Kokushi in Hakuin's *Kaian Kokugo*, form a couplet with "New blossoms grow out on old branches."

Bamboo lives through the cold winter without losing its green color. In fact, bamboo actually grows in the quiet chill of winter, staying strong and cultivating its essence. Even in the snowiest season, regardless of how thin and fragile it appears, bamboo can hold a heavy load of snow. It represents that which perseveres in difficult circumstances, as does the plum blossom opening in the snow. In the spring the bamboo shoots are a sign of vivid new life and are harvested as a delicacy. The shoots grow from the roots of the older bamboo, just as the plum flowers bloom from a parent branch on the tree. Old and new bamboo are one; they share one subtle world.

There's no greater value in life than thinking of one's descendants. In the Lotus Sutra, the Buddha expressed this state of mind with the story of Choja Guji and the children who are afraid to leave the burning house. In this story Choja represents the Buddha, and the children are sentient beings. The children are trapped in the world of form, represented by the burning house. Choja uses expedient means to get the children out of the house, telling them that carts pulled by various animals are outside. The carts represent the various vehicles for awakening to the true teaching.

The Lotus Sutra tells us that, after hearing this story, those assembled practiced industriously and were able to realize freedom from suffering. If we open our Buddha eye, we are seeing with the very eye of Buddha. When we open this eye that sees everything, then even if we do not cut away every desire, we can become a Buddha. The seeking mind and the guiding mind join and share one subtle world.

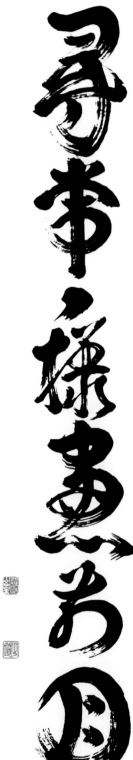

尋常一樣窓前月

Jinjō ichiyō sōzen no tsuki
The moon by the window is always the same

When we look out the window at the moon, it is always the same moon. But if any thoughts or desires come between us and the moon, what we see changes completely. In Original Mind, everything is one and the same. Our Original Nature is deep and clear and bright. One who when seeing becomes the seeing, when hearing becomes the hearing, who becomes the very thing itself, is an eternal living Buddha.

There is nothing but this in the Buddhadharma, and there is nothing *beyond* this. Any analysis we make about it is a mistake, only adding clutter after the fact. When we live with no separation between ourselves and what we are experiencing, we know the truly bright and clear Mind that is our Original Nature. But as long as we carry around an ego filter, it's impossible to experience this.

To clarify ourselves to this point is the Path of the Buddha. We have to let go of everything we get caught on. Then we can receive this world with a fresh awareness and a true life energy. The moon is always shining brightly, but we have to see it ourselves, directly. When we know it deeply from our True Mind, it's not just scenery but a slice of our own Original Nature.

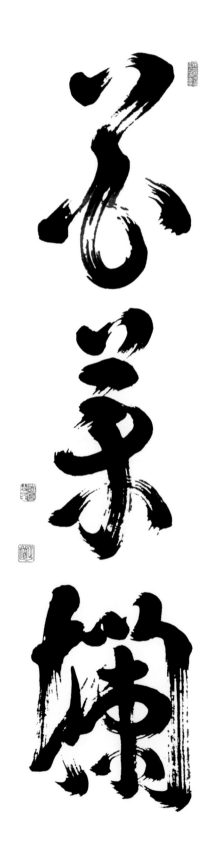

花薬欄

Kayakuran

A flowering hedge

This phrase is from the thirty-ninth case of the *Blue Cliff Record*. It is attributed to Master Unmon Bunne, the founder of the Unmon line.

Once a monk asked Master Unmon, "What is the pure body of the Buddha?"

Master Unmon replied, "A flowering hedge." Unmon was asked about the source of the universe, the pure body of the Buddha, and he answered by pointing to the hedge surrounding the toilet. What kind of an answer is that? How can the hedge that hides the toilet be the pure body of the Buddha? The purest thing is asked about, and the least pure thing is given as the answer. The absolute is being asked about, and the differentiated is given as the answer.

Looking closely, we see that this is the only way Unmon could have answered. If he is presenting that which surges through the whole universe, vertically piercing through the three realms of time and horizontally extending in the ten directions, if this really is the root source of the koan of Mu, then it needs to reach from the heights of heaven right down to that toilet. If it doesn't reach all the way down to the maggots in that toilet, it's not the root source of Mu. If we try to say that everything is clean and pure except for the toilet, that's not the true Dharma. There's no all-seeing Buddha there. If even the tiniest speck of anything is disliked, it's not the pure body of the Buddha.

If we don't yet have eyes that see beyond differences, then we'll jump to conclusions and go nowhere fast. Only when we can go into the midst of society without anything extra in our minds will we be able to function without being caught on the differences around us.

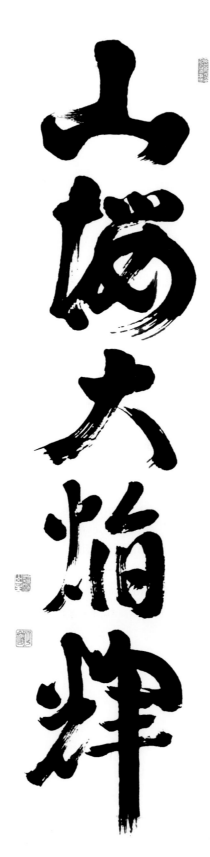

山桜大焔輝

In the mountains the cherry blossoms are blooming, one thousand at the foot, one thousand on the slopes, and one thousand at the top. The mountains are on fire with cherry blossoms; springtime is at its fullest blossoming.

There are many ways in which we can compare our lives to the flowers' blooming. Everybody who is born wants to live a good life. But we can easily mistake the Path to happiness. True happiness isn't about acquiring knowledge or gifts from others but about realizing our own great fortune in the radiance of our very own life. All beings are born to realize this Buddha Nature directly.

Master Reiun was enlightened at the sight of a peach blossom and wrote:

> For thirty years no guests came by;
> The leaves fell and the branches became bare.
> Seeing one peach bloom,
> The time has come,
> There is no doubt left whatsoever.

For thirty years Reiun worked on obliterating every deluded thought and view. While tending to this internal housecleaning, day in, day out, he welcomed the autumn and spring so many times he lost count. With the sight of the peach flower, in bloom at that very moment, thirty years were swept away. Reiun's huge Mind, freed of judgments and opinions, provided no quarter for doubts to arise.

As Bodhidharma said, "One bud opens its petals and naturally grows into fruit." Our zazen gives blossom to the flower of Mind. This is the true source of joy.

青山不老春長碧

春山靑春水碧

Seizan wa aoku shunsui wa midori
Spring mountains are green, spring rivers are blue

Zen teaches of that face, present long before your mother and father were born, that reveals your Original True Nature. That awareness prior to the birth of any awareness, before the creation of the heavens or the earth, how is that for you? That place of dying completely to everything in this world, of having realized that boundless state of mind—how is it there? This is the same place as the source of Mu before any notions or questions or thoughts can enter; this is the very foundation of our state of mind. It is that place where the heavens and the earth and I are one, where there's not yet any division into good and bad, where I am in no way separated from anyone or anything, where not one mind moment has been born. How about right there? What is the actual substance of our awareness? This whole world—what gives birth to it and its perception?

If we are careless, we might answer something like emptiness or void. We shouldn't fall into that pit. In Zen, this kind of nihilism is called the dark fox's cave and is warned against. Turning your back on the pain and suffering in the world, or placing yourself as the center of the world and paying no attention to anything else, is not the Buddhadharma. The Buddhadharma does not sell as cheaply as that! The Buddhadharma is the activity of liberating all sentient beings in the whole world—if it's not this, it's not the Buddhadharma.

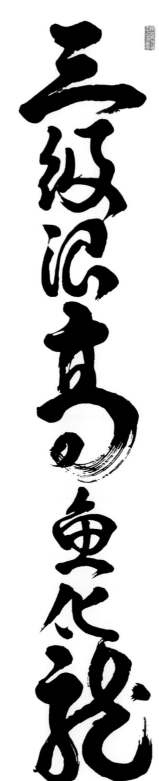

三級浪高魚化龍

Sankyū nami takōshite uo ryū to ke su
At the three-tiered Dragon Gate, where the waves are high, fish become dragons

This line is from Setchō's poem to the seventh case of the *Blue Cliff Record*, "Echo Asks about Buddha." In March, when the peach flowers begin blooming, the carp gather at the bottom of the three falls on the Yellow River known as the Dragon Gate. Legend says that those that are able to jump to the top of the falls become dragons.

After training hard for six years and setting everything aside to actualize life energy directly, the Buddha saw the morning star and knew himself as that very star, with no separation between inside and outside. If we, with all of our delusions and flawed ways, can completely pass back up that waterfall, our habits of thinking and presuming are swept away, and we become a dragon that can fly through the sky. Losing obstructions, we gain our freedom. To pierce through conceptual thinking and mental baggage, we clarify our being with the same effort and determination used by the carp to ascend the falls. When we put everything on the line, we know the state of mind of the Buddha.

Some people can't understand why it is essential to follow all the way through to the end. Those who have done so don't look different on the outside; what changes is how they function and live. Saying that we're going to die anyway, that awakening won't change whether we get hungry or stop world crises, is to deny that truth. People who can't see the value of refining their state of mind will forever be at the mercy of their body and its needs, tossed by emotions and thoughts.

Each person who awakens can enable and guide others to awaken as well, just as the Buddha's enlightenment still influences the enlightenment of others today. But while the Buddha's awakening has been kept alive for 2,500 years, if no one continues this work, there won't be anyone left to tell future generations about it. No matter how many words and records are left behind, those who have not realized Buddha Nature directly won't be able to touch its deep truth. Because of this, the awakening of each person is essential.

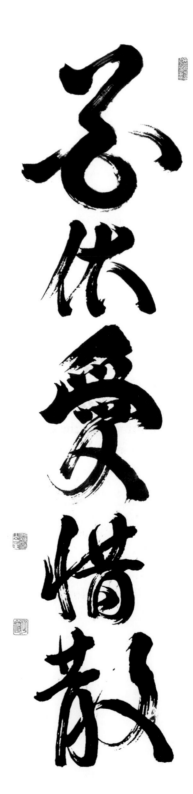

花依愛惜散

This line forms a couplet with "The endangered weeds come up once again."

As long as humans have existed, we have appreciated the bounty of nature, cultivating food and gathering what we need while discarding what we can't use. We have domesticated animals and designed tools to assist us in our work. At the same time, we have tried to eliminate plants that are poisonous to us and to destroy beings such as cockroaches and ants that we consider bothersome. We appreciate flowers for their beauty, and we pull plants we consider weeds. In pulling the weeds we are subjecting those plants to our preferences, even though in nature flowers and weeds are equal.

Without thinking of good or bad, how, at this moment, do you receive the world? This is the foundation of the truth, a truth that can be directly realized only from within. To see what is true we must let go of our selfhood, our personality, our entity, and our separate individuality. These limit and restrict, putting us in the shadow of I, me, mine and making this world a hell. The idea of a "me" is incompatible with humans' basic way of being, and when we act from there we destroy the world. We must have a vow that reaches beyond our own limited interests and extends not just to all beings but to everything in the natural world as well.

Our ego is not necessarily bad. But if we only use it for self-satisfaction, instead of for all beings, we're ignoring a wider responsibility. We have to take care of the ecosystem and not just use its bounty for our personal needs. We have a responsibility to save this world for all future generations, without resenting the effort this requires.

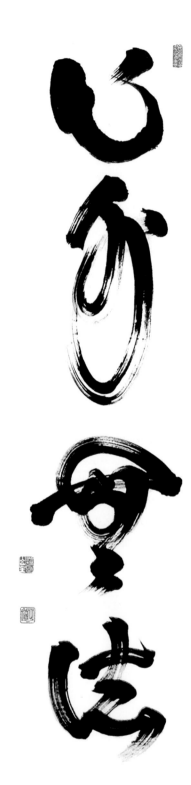

じうかうむ生

心外無法

Shinge muhō
Outside of mind there are no things

This phrase is taken from the text known as *The Transmission of the Lamp*. There we find the entire verse: "Outside of mind there are no things, but the eyes are filled with blue mountains."

The words are those of Tendai Tokushō. When Tokushō first visited Master Hōgen, he did not do sanzen, believing he had no more to realize. While Master Hōgen was teaching the assembly, Tokushō sat with the other monks. From within the assembly one monk came forward and asked, "What about the one drop of water of Sōgen?" This phrase, "the one drop of water of Sōgen," refers to the true marrow of the Dharma teaching of the Sixth Ancestor.

When Hōgen heard the monk's question, he quickly replied, "That *is* the one drop of water of Sōgen!" He was saying, "Isn't that which is asking itself the one drop of water of Sōgen?" The monk did not get it. But Tokushō, who was sitting in the back of the room, upon hearing this was instantly deeply awakened. The very base of his mind was pierced through.

The lines in which he expressed that state of mind describe the scenery of Mount Tendai, a world that is entirely new, in every direction and as far as the eye can see. Our state of mind is one and the same with the blue mountains, one and the same with the heavens and earth. That which is seeing the mountains and that which is being seen, those bright blue mountains, are everywhere. If the mountains are endless, then I too am endless. There is no life or death here, beyond any limits of time and space. Tokushu was saying that thanks to his realization he had experienced true serenity and stillness within. He had become that state of mind of being one with the heavens and earth.

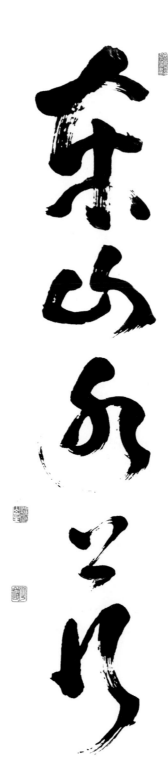

東山水上行

In the fifty-seventh case of the koan collection entitled *Entangling Vines*, Master Tōzan is asked, "From where do all the Buddhas come?" He answers, "The east mountain walks upon the water." Another monk asked Master Unmon, "From where did all of the Buddhas in this world come?" Master Unmon replied, "Master Tōzan answered, 'The east mountain walks upon the water.'"

Tōzan seems to be saying that the mountain starts flowing down the river. But what his phrase in fact describes is the mind state in which the mountain and I are one and the same. As we walk along the quietly flowing river, we too begin to flow quietly, and all of the great mountains along the river begin to flow quietly as well. Is the water me? Is the scenery me? Is the flowing water disappearing? We open into that state of mind of no mountain, no river, no self.

We don't have to go to the river to experience this. We experience it every day when we cook, for example, without thinking about the pots and utensils or about the body's movements; this is how we make the best food. To experience this is to understand the Buddhadharma.

To know the mind of this moment, we do zazen. As the Sixth Ancestor defines it, the *za* of *zazen* is to not add any ideas of good or bad onto what we perceive. When we do this, we are not moved around by anything that comes forth; nor is our thinking rigid or petty. We work with all of our energy. The Sixth Ancestor defined the *zen* of *zazen* as holding on to nothing at all within our mind. We are not trying to do good or be thought well of; instead our mind is always full and quiet. In keeping with what Master Dōgen says, to chase after the myriad things is delusion, to allow the myriad things to come to us is enlightenment.

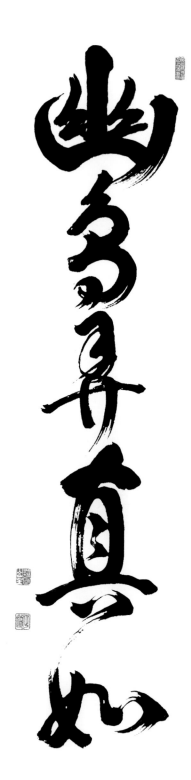

幽鳥弄真如

Yūchō shinnyo o rōsu

The hidden bird is playing with true suchness

This phrase forms a couplet with "The old pine is speaking prajna wisdom."

Both the wind in the pines and the song of the birds offer the teaching of the Dharma. Arising early, we hear the beautiful song of the meadowlark. Doing training together, reading the sutras, going to sanzen, there is not a single moment for rest in the schedule, no gap at all. Sometimes, when we think about slowing down and taking a break, Nature's voice calls—we think that to sit back and listen to the voice of the meadowlark in the mountains would be heaven.

In the spring we see many varieties of flowers—these are heaven too. In the summer, after working hard, we sit down in the shade and listen to the song of the wind chimes. It's as if the cool evening has come right to us. In the autumn we see brightly colored leaves everywhere we look. In the winter, the snow turns everything into one solid layer of silver. Isn't this paradise?

If our mind is clear, all conditions are heaven. If we're not angry and resentful and full of negative energy, whereever we are is always the best season. But when our mind is full of ego and desires, we aren't able to know this. When we hold on to nothing, we awaken to the wisdom of prajna and widely open our original eyes of Truth. This place, as it is, is the land of lotuses. When we know this very Truth as it is, everything is wondrous.

錢塘苏不劫外去

鐵樹花開劫外春

Tetsuju hana hiraku gōgai no haru
The iron tree blossoms, and the whole wide world is spring

Dōgen wrote in the *Shōbōgenzō* about the most basic koan of all:

> To study the way is to study the self;
> To study the self is to forget the self;
> To forget the self is to be enlightened by all things;
> To be enlightened by all things is to remove the barrier between self and other.

Learning the Buddha's way doesn't require grasping grand concepts or mastering exotic philosophies. It is not about contemplating the beginning of the universe or learning how to earn more money. Nor is it about being respected by others for following some noble truth. When you encounter your own Self, you will discover the true Buddha.

That's why the Buddha said to look inside ourselves and take refuge there, rather than looking for refuge elsewhere. This self is not something that can be known conceptually but is that which perceives through all of our senses and apertures. *Awareness-experiencing-awareness* is another way to describe it. We must let go of all ideas of form, of being male or female, old or young, rich or poor, good or bad. Right there, a huge, wide-open state of mind is born; right there, the flower blooms on the iron tree.

Anyone who is alive will eventually die, and anyone who laughs will eventually cry, but all of it is Mu. Born as a human in this world, we can know this awakening of our True Mind. When all day long we experience the Truth directly, whether we are coming or going, then the iron tree gives forth a flower. We will see how wonderful it is to be human and know that this is the greatest good fortune. To realize this directly is the most important thing we can do.

百不老五為進乎

百花春至爲誰開

Hyakka haru itatte ta ga tame ni ka hiraku
The hundred flowers that come with the spring, for whom do they bloom?

In the spring, flowers bloom everywhere. For whom do they bloom? They bloom for no one; beyond a "self" and an "other" they bloom. Beyond subject and object they bloom. They are of the world that exists beyond any division into two, the mysterious world of the not-two. For whom does the breeze of summer blow? For whom does the autumn moon radiate and shine? For whom is the winter snow so pure and bright? These exist not for the sake of our private minds or merely as phenomena in the world. When the world and we become one, each and every phenomenon shines with Truth, a Truth that we must each experience directly. When we realize this Truth, we know the place where we can add in no extra thoughts or ideas. This is Zen. Here the ultimate great joy and happiness are present. What could be more joyful than the pure blooming of phenomena into the way of the world?

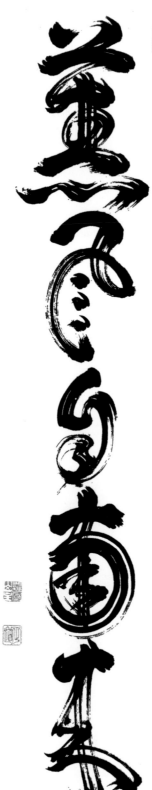

薫風自南来

Kunpū minami yori kitaru

A fragrant breeze comes from the south

These words, written by a poet of the Tang Dynasty, are about the ways of nature, but the Zen mind can be found in them as well.

The wind that blows from the green woods has a clean and fresh fragrance that can revive and liberate the body and the mind. While the wind from the north is strong and robust, and the wind from the west is also powerful, the breeze from the south is soft and gentle and fragrant.

Our essence of mind constantly changes in response to the environment. In the terrible heat of summer, those who work and sweat outside, with no green forest in sight, and those who cannot sleep at night because of the heat that lingers in houses without air-conditioning, beg for autumn's coolness to come even one day sooner. But the high temperatures of summer are not the only heat. Even when the weather is cool, a pain in the heart can make us hot and uncomfortable. We need to let go of any idea of good and bad and let the cool breeze blow in our mind. Letting go of thoughts of good or bad, pretty or ugly, sad or glad—letting go of those thoughts that we fight with and become so hot about—doesn't change the reality of the heat, but we are no longer pulled and pushed around by those thoughts or suffer pain because of them.

Within the mind is a place beyond dualistic perception. Even if we have problems in our lives, when we cut away all thoughts of good and bad and enjoy the evening cool, we know the state of mind of the Buddha. If we have the spaciousness to swallow down everything and take it all in, then any time, any place, the fragrant breeze is blowing.

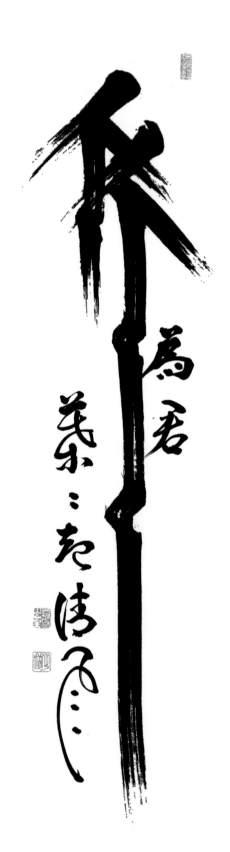

為君

莱；老清風

竹
為君葉々起清風

Take
Kimi ga tame ni yōyō seifū o okosu

Bamboo
For you the clear wind rises

As the wind blows across the bamboo grove, causing the bamboo to sway, we feel cooled. From far away good friends have come to visit. They are on their way to another destination, and the visit is short, even though we haven't seen them in a long time. As dawn breaks, it's time for them to depart. As they say goodbye at the main gate, the wind is blowing and the bamboo in the grove is swaying, and it is difficult to part, not knowing if we will meet again in this lifetime. Our encounters are always moments of "one encounter, one opportunity."

In Buddhism we say: "Where there is birth there will be death. Where there is meeting there will be separation." To meet is the beginning of parting; meeting must always be accompanied by separation. Although we might meet again, this moment will never be duplicated. Yet even when we can be together for only a short time, that mysterious karmic connection is something to be deeply thankful for. It is a truth of our life that each time we encounter someone, every moment of that meeting must be held precious.

In life we are always traveling. Within that journey, we can be thankful for each of the many people we encounter and wish each one all the freshness of that pure wind.

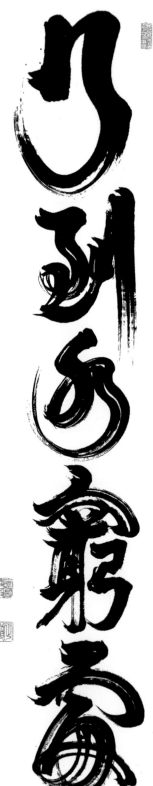

行到水窮處
坐看雲起時 *(overleaf)*

Yuite wa itaru mizu no kiwamaru tokoro
Zashite wa miru kumo no okoru toki

Walking, I reach the place where streams run out
Sitting, I see the moment when the clouds arise

In his definition of zazen, the Sixth Ancestor says that *za* means to not add any thoughts or concepts such as good or bad to that which arises externally. When we receive each thing just as it is, just as it comes to us, we are not caught on a small self. We do this not by struggling, but by drinking down everything that comes along without imposing any judgments, going beyond all dualism and simply reflecting whatever comes. Swallowing everything down, we don't feel small or narrow. This limitless essence of mind is *za*. Zen is to know our mind's essence from within, with nothing lingering there at all. We need to establish that inner essence firmly and not be moved around by external things, receiving everything as it is and holding on to nothing. To see within and not be moved by anything that comes along is zen.

We become like a mirror that reflects exactly what it sees. If a man comes in front of it, the mirror reflects a man; if a woman comes in front of it, it reflects a woman. It reflects an old person as an old person, a young person as a young person, a sick person as a sick person. Our mind is capable of clearly seeing the good and bad aspects of everyone. But if we pass judgment on another based on what we see, we are thereby giving importance to our own position. Because we can't hold two points at the same time, if we hold on to our position we become caught there.

When our mind does not move to criticize and judge, we reflect things exactly as they are. We can then work freely, and our mind's essence is stable. This is the subtle flavor of zazen. In each and every moment's encounter we know the truth. The essence of these continuing clear mind moments is zazen. Zen is to see everything around us broadly while also doing the work that is before us. Functioning in this way we know the mind of zero,

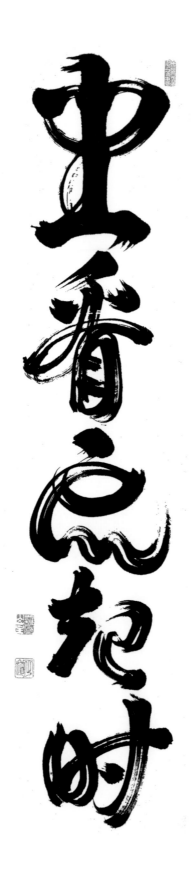

上看香风起舞时

like a mirror that adds nothing to what it reflects. Yet it is not about being void. We are full and taut in very part, and without losing our essence we know deep samadhi.

The Sixth Ancestor said, "Cut off all ideas of good and bad concerning the outside world. Then without giving rise to any ideas of what rises and falls, we sit." This is the world of "Walking, I reach the place where streams run out; sitting, I see the moment when the clouds arise."

雨後青山青又青

雨後青山青転青

Ugo no seizan sei utata sei
Green mountains after rain, the green is even greener

On a bright, clear day in May, Master Butchō went to visit the hermitage of the poet Matsuo Bashō. Bashō had told Master Butchō that he wanted to meet with him and have sanzen. Upon seeing each other, the two smiled broadly.

Butchō asked, "So, what have you realized?"

Bashō answered, "The rain has ended and the mountains are greener than ever. The moss is so bright, even greener than before!"

Butchō could not accept just that. He asked, "What is the Buddhadharma prior to that bright green moss?" He was asking about that pure transparent source of awareness prior to any division into good or bad, prior to any duality, prior to even a single mind moment. People often misunderstand the "empty" state of mind of zazen as nihilism. Butchō was making certain Bashō had not made that error.

An answer came flying back: "Jumping into the river, the sound of water." At that moment, something had broken the stillness by jumping into the water. Most likely it was a frog, and this "plop" filled the ears prior to any division. Bashō expressed clearly that place without any preconceived notions, found in the very moment's immediate encounter. He expressed pure awareness.

Butchō verified that Bashō had realized the Truth. From this came, it is said, the famous poem:

> Into the old pond
> the frog jumps—
> *plop.*

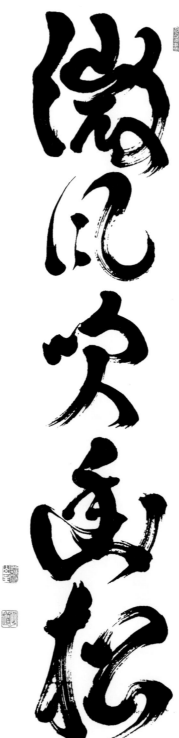

微風吹畫棟

微風吹幽松

In the Tang dynasty in China, two eccentrics, Kanzan and Jittoku, lived on a mountain named Tendai. Although many sought to find them, all that was ever found was a set of Kanzan's poems written on a rock. This line is from one of those poems:

> Looking for a refuge
> Cold Mountain will keep you safe
> a faint wind stirs dark pines
> come closer the sound gets better
> below them sits a gray-haired man
> chanting Taoist texts
> ten years unable to return
> he forgot the way he came

Most people think that cultivating the ego is the route to success and good fortune. Believing that the more knowledge we have the more valuable we are, we look for something beyond imagination. Yet it is a big mistake to carry around memories about how things were ten years ago. Only when we let go of the past can we live each new day with a fresh and new state of mind.

If you want to know this place free from the world's pain and suffering, it can be found here in this deep mountain. Of course Kanzan was not writing about isolation from the world in a literal sense. There is a cold mountain in the mind of each of us where nothing can be heard. In this quiet mountain's depths a slight wind moves the pines. The faint rustling of the boughs resonating within the deep quiet is poignant. And at the foot of that old pine sits Kanzan, reading the works of that far-reaching mind where all is equal.

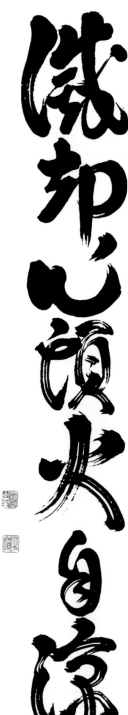

但知心頭火自涼

滅却心頭火自涼

Shintō o mekkyaku sureba hi onozukara suzushī
Once mind is extinguished, even fire is refreshing

When we go beyond our dualistic thinking, even the hottest weather, so hot we feel as if we are on fire, can become as refreshing as a cool breeze.

A monk asked Master Tōzan, "How should I look at the ultimate edge of life and death? This heat is unbearable! How can we resolve the tortures of hot and cold?"

The master responded, "Why don't you go where there is no hot and no cold?" He was pointing toward that place of no birth and no death.

The monk answered, "This place of feeling nothing—where is it?"

"You have to cut away all the dualistic feelings of 'hot!' or 'cold!' You have to let go completely of even the slightest sense of hot and cold."

When living, live completely! When dying, die thoroughly! This is the state of mind described in "Once mind is extinguished, even fire is refreshing." Our mind has a quiet, deep stillness, a stillness so profound that no happiness or sadness can reach there. To know this great depth is to be in Nirvana.

The way of liberation from all pain and suffering is to extinguish the flames of anger, greed, and ignorance. Here can be found the true way of liberation of the Buddhadharma.

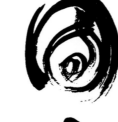

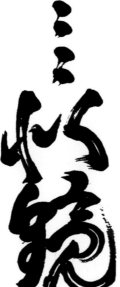

荷葉團團似鏡

The lotus is often used to represent Buddhism, symbolizing the subtle and mysterious Dharma. Lotuses are offered on Buddhist altars, and the Lotus Sutra is considered the king of all sutras. When the Buddha taught the Buddhadharma, the lotus represented the center of his teaching, as it does the center of the Mahayana teachings today.

In the Vimalakirti Sutra it is said, "Just as the lotus, born of mud, is not tainted thereby, so the lotus of the Buddha preserves the realization of voidness." The lotus is not found blooming in the pure air of a mountaintop, nor is it found in clear bodies of water. Instead, it blossoms in muddy and stagnant pools. Yet the flower itself, rising above the mud, is known for its purity and clarity. When it blooms, its fruit has already been produced. It does not finish flowering before producing its fruit. Likewise, in Buddhism we do not need to find a pure, clean location in order to discover enlightenment, nor do we first have to cut our desires away completely. Right here within the mud of our desires, we find the flower of enlightenment blooming. Right within our delusions, amid our impurities, we find our heart opening and our mind awakening.

If we give rise to our Bodhisattva Vow, then our fruit of becoming Buddha is guaranteed. This is the deep truth of Mahayana Buddhism. The Buddha's round, huge, perfect Mind of no corners and no edges is expressed by the big round lotus leaves. Yet, although we say that the Buddha had a round great Mind, this does not mean that he was always smiling. He was very strict with his disciples. Even though each of us already has this deep life energy, it does not mean that we can do whatever we feel like. Rather, it means that we must live with compassion for all people, in a way that gives life to all others and our own freedom simultaneously. We must understand this subtle interaction of all things, or it is not the true Buddhadharma.

南をわ北をゐる一乘

南村北村雨一犂

Nanson hokuson ame ichiri
In the village to the south, in the village to the north, they're plowing after the rain

Everywhere you look in the wide-open countryside there are rice fields. From morning to night, everyone works as hard as they can. The men drive the oxen in order not to waste precious daylight, while the women hull the rice and prepare food. Children gather fuel for the fires, and the old folks care for the toddlers in the shade of the big tree. Suddenly, billowing clouds drop water that darkens the plowed furrows and sends everyone scurrying to seek shelter under the big tree. At noon in the kitchen, a young bride brings lunch for her mother-in-law, and the father-in-law chews food for the baby. Without any attachment, each person does what is there to be done. This is the source of peace.

The poet Kotei Ken, who wrote this line, studied with Master Shishin Goshin. One day in sanzen he asked, "Where can the Path be entered?" Shishin Goshin responded, "Can you smell that?" Kotei Ken looked at the garden fence, where the sweet olive was blossoming. "Yes, I can smell it." "Well, enter from there." Shishin Goshin taught him in this way.

Knowing this energy that lives through us in this very moment brings us joy in everything we do. Raising children also polishes the parents and brings them happiness. In life there is a joy of children that only children can know, and a joy of being a young person that only a young person can know. There is also the true joy of simply being alive, which can only be known by separating from everything.

Our training is not about doing something difficult to become something special. Chanting sutras, doing prostrations, working, we receive this very moment, and for that we have eternal gratitude. In every single thing we do, we find Buddha. In knowing that we are alive today, we find our greatest grace and joy.

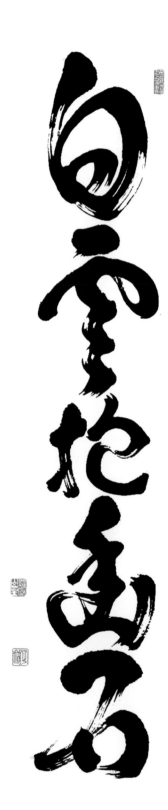

白雲抱幽石

白雲抱幽石

Hakuun yūseki o idaku
White clouds clinging to dark rocks

This line is from another of the Cold Mountain poems.

> Towering cliffs were the home I chose
> bird trails beyond human tracks
> what does my yard contain
> white clouds clinging to dark rocks
> every year I've lived here
> I've seen the seasons change
> all you owners of tripods and bells
> what good are empty names

Kanzan chose to live where the tallest mountains pierce the sky. No other people journeyed here. In this place of full, spacious, and open living, all that he could see were the white clouds passing, the huge rocky peaks poking into the sky, and the birds flying past. He had no need for the possessions of society or for any fame or recognition.

True satisfaction won't come from superficial beliefs. In our true spiritual home all is equal, full, and unchanging; it is the world of actually awakening to this clear Mind. We take this true absolute awakening, this singularly clear state of mind, and for a short while we give it the name *Zen*. The Buddha taught, "Those who see the Dharma see me; those who see me see the Dharma." The Dharma and the Buddha are one and the same; they are not two. This is the Mind in which there is only one great vivid and alive life of awe and wonder.

We are not living for tomorrow, nor looking back at yesterday's problems. Right here, right now, in this very moment, we find the time that reaches from the infinite past into the infinite future, and the infinite space into which it opens, and we drink it down. Without this great wonder and joy, where is there value in having been born?

At least once, we have to taste this state of mind of "White clouds clinging to dark rocks," beyond living and dying, in which not one obstruction remains.

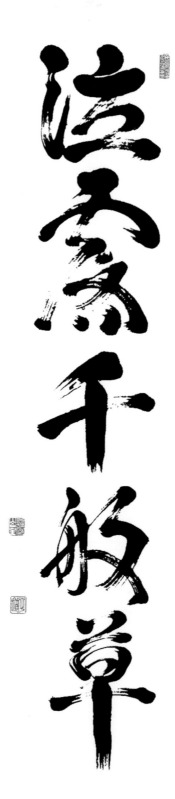

泣天窬千般草

泣露千般草
吟風一樣松 *(overleaf)*

Tsuyu ni naku senpan no kusa
Kaze ni ginzu ichi yō no matsu

Myriad plants weep with dew
The pines all sigh the same

These lines are also from the works of Kanzan.

> The Cold Mountain Road is strange
> no tracks of cart or horse
> hard to recall which merging stream
> or tell which piled-up ridge
> a myriad plants weep with dew
> the pines all sigh the same
> here where the trail disappears
> form asks shadow where to

The Path of Kanzan is not of the world—no vehicles travel along it; no carts or horses or people come and go; there are no footprints or traces of habitation. The valleys take so many twists and turns, I can't remember from which direction I came. I have seen so many mountain ridges, I've lost count. The thick, dense grasses are crying with the dew drops that have formed upon them; the pines are singing with the winds that blow through their branches. Here in these mountains, if I miss a turn or become confused, the me that has a form has only to turn in the direction of the shadow of myself and ask, "What path are you traveling?"

Thus Kanzan sings of his world. His Cold Mountain is the mountain in the mind of each of us—people and vehicles and horses cannot pass there. Ridge after ridge, these mountains continue endlessly. This scenery is the state of mind where I have become one with the heavens and earth. If we look at our lives, we see how many thoughts we constantly pursue. When we forget our everyday concerns and melt into the endless mountain, we

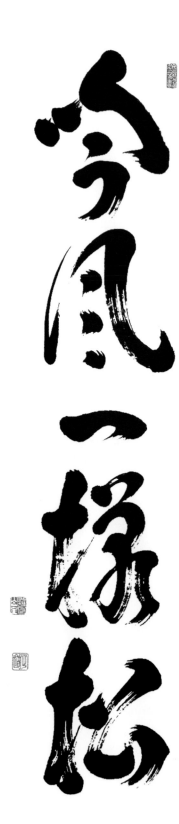

know the state of mind of forgetting ourselves altogether. Here there is no good or evil, no failure or success, no resentment or pride, no sadness or happiness. This is the world of absolute Mu.

If we can awaken to the state of mind of Kanzan, we can know that deep wisdom and bring it to life. No matter how hideous the world in which we find ourselves, we do not need to be caught by it. But, as Kanzan tells us, it's not so easy to understand that this world of frantic noise, crime, and sorrow, just as it is, is the land of lotuses. Even while we are enslaved by our egos, not knowing what evil this bag of shit will do next, this very body is the body of the Buddha. While we remain caught and driven by ego, diving headlong into the world of Buddha is not a casual act.

Kanzan is not simply ignoring the dirt of the world and writing only of the higher realms where the birds fly. Diving into this world where everything is equal, we can become this state of mind of clarity and ease, smack dab in the middle of those crying grasses. We can know the absolute Mu where we can't see left or right. But if we are stuck in the world of angry beings, we can't discover true wisdom; the world will continue decaying, and infinite numbers of people will continue to be murdered. For this great suffering, the tears of dew are being wept.

The great wind that blows through everything isn't only for our own pleasure. Nor is it the wind of an all-consuming hell that agitates and disturbs all we see. The world of Kanzan isn't a world of saving only oneself. We have to look deeply within and inquire.

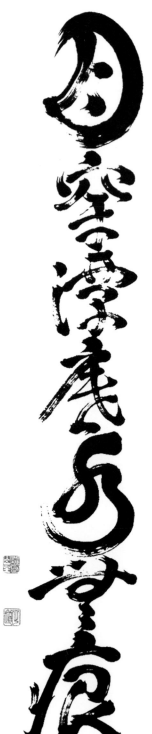

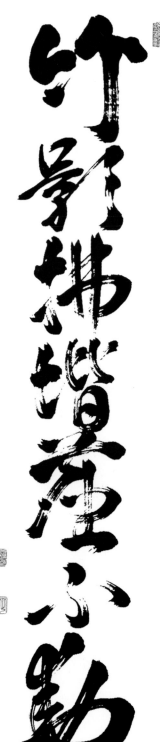

竹影掃堦塵不動
月穿潭底水無痕

Chikuei kai o haratte chiri dōzezu
Tsuki tantei o ugatte mizu ni ato nashi

Bamboo shadows sweep the stairs, yet not a mote of dust is stirred
Moonbeams pierce the bottom of the pool, yet leave no trace in the water

These lines can be found in the fifth section of Hakuin's *Kaian Kokugo*.

The infinite emptiness of this immense universe has no beginning and no end. All things, in their natural way of existing, teach the truth of no death. When the shadow of the bamboo sweeps across the stairs, not a single speck of dust moves. The moon's light pierces to the bottom of the pool, yet not the slightest scratch can be seen in the water.

In our world there exist joy and sadness, love and hate, good and bad. All manner of feelings arise side-by-side. One who can live amid these complexities and not be buffeted by their winds and waves is a person of true wisdom. The Buddha, who himself realized this deep wisdom, said, "The good renounce everything. The virtuous do not prattle on about yearning for pleasures. The wise show no elation or melancholy when touched by happiness or sorrow." These words can be found in verse 83 of the Dhammapada.

The Buddha teaches us to have a mind like a mirror and not be caught by the ego. The mind with which we were born can receive everything exactly as it is, but because of ego's clutter, because of attachments to our views, we aren't able to remain in this mind of clarity. It has to be said that this society and its people are very sick.

Yet the moon of the Bodhisattva Vow floats always in the air. "If the pure water of clear Mind in an ignorant person is realized, the moon of Buddha Nature is always there, alive." This is how it's written in the Flower Garland Sutra. With the mind clarified, we awaken in truth.

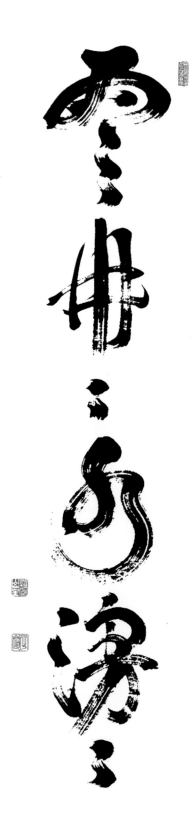

雲冉冉水漫々

Massive clouds appear and then fade, one after another, without end, and their waters replenish the whole universe without ever stopping. We have to know directly this Mind where we become the flow of the clouds, where we become the water's ebb. For one who has realized this Mind, there's nothing to fear. Wherever something needs to be done, we respond without being asked. It's not about living in a tiny ego world; it's about forgetting our selves and diving in, making society our body and allowing the universe to be our life energy, continuing this functioning whether we are waking or sleeping. If just one person is like this, the world will be brought back to life and revived.

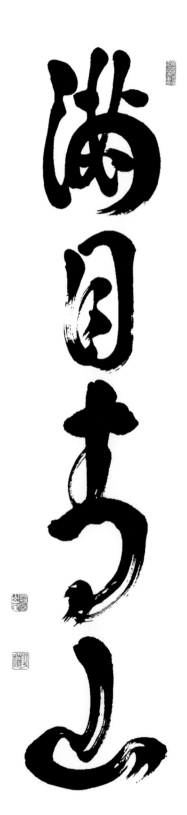

満月まつり

満目青山

Manmoku seizan

The eyes are filled with blue mountains

This phrase is a companion to "Outside of mind there are no things."

As a young monk, Hōgen Buneki visited Jizo-in temple. One day he spoke with the master there, Jizo Keichin, about Jō Hōshi's words, "The heavens, earth, and I are of one root, all of the ten thousand things and I are the same." Jizo Keichin asked Buneki, "Are you and all the things in existence the same or different?" When Buneki replied that they are different, Jizo Keichin spread two fingers and said, "There. They are already separated." Buneki answered, "The same!" Jizo Keichin again put out two fingers to say that they were separated again. Buneki could not respond to this clearly and pondered it deeply.

Later, as Buneki was planning to leave, Jizo pointed at a nearby rock and asked him, "You said that all things are within your own consciousness. So is this rock inside your mind or outside your mind?" Buneki said immediately, "This is only in our mind." Jizo sighed and said, "Here you are going on a journey and you have to carry along this heavy rock! What a terrible thing!" Buneki understood but had no clue how to answer. He decided to stay with Jizo and continue undergoing his deep interrogation.

When Buneki asked Jizo to please teach him, Jizo replied, "You have to bring the Dharma from your own belly and not rely on someone else. Then you will truly understand how all the teachings are within you." Upon hearing these words, Buneki instantly felt all of his confusion and doubt disappear. He knew the eternal truth in the one instant of the present: the heavens and earth, as they are, are my body and all of the world in all of the ten directions is me. Everything in the universe is me, and that is the Pure Land.

This is what is meant by seeing the truth in ourselves. We find refuge in our own True Mind. Rather than being limited to a small self, we become the sun shining, the mountains soaring, and the autumn wind blowing. Zazen allows us to become this clear huge Mind.

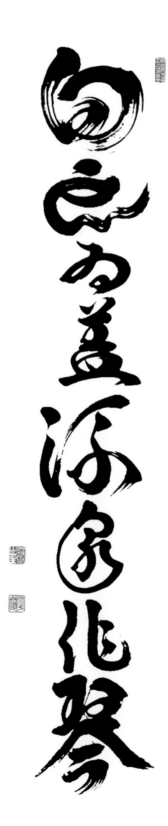

白雲為蓋流泉作琴

Hakuun wa kasa to nashi, ryu sen wo koto to nasu
White clouds crown the heavens; the streams draw music from the harp

This line is from Setchō's poem to the thirty-seventh case of the *Blue Cliff Record*.

Banzan Hoshaku left us a phrase that splendidly expresses the Dharma: "In the three worlds, there is no Dharma. Where could you find the Mind?" The three worlds are those of desire, of form, and of formlessness. We all live in the same physical world, but there are many ways of seeing it. One person lives according to his desires; another has fewer desires but is caught on form and doctrine; another who is not attached to material things may be attached to art and philosophy. Even while living in a world that arises and passes with karmic affiliation, people get caught in their views. What we all have in common is delusion.

Nothing is eternal or fixed. There is not one thing that can be called *It*. The flowers we see in the garden constantly change, as do the moon and the stars. The mountains and the rivers rise and recede. We constantly change with the ebb and flow of the world; thus, if the world is empty and void, we have to be empty and void as well.

Since nothing is eternal, where is there a Buddha? If you think there is such a thing to depend on, that's a mistake. As the world changes, mind changes as well. So where is this absolute thing called mind? Banzan Hoshaku was not fixed in either an objective or a subjective view. He was beyond such dualism, and he asks us to grasp that!

Setchō is telling us to look at the immense blue sky. The clouds are moving along leisurely; they are like an umbrella over our heads. At our feet, the valley stream makes music as it flows. If just once we embrace this truth simply and completely, we will know "White clouds crown the heavens; the streams draw music from the harp."

This functioning is not something we can learn at school or read about in a book. It's part and parcel of the Buddha Nature that we have from birth, beyond any mental understanding. "In the three worlds, there is no Dharma. Where could you find the Mind?" This is Banzan Hoshaku's state of mind. Banzan, the Buddha, each one of us—we all see the white clouds and the flowing stream with exactly the same eyes.

When we know that Pure Mind with which we were born, then everything we see and hear is brand new. That is the truth of our Buddha Nature.

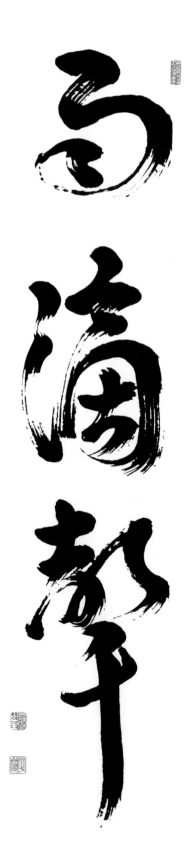

雨滴声

Uteki sei
The sound of raindrops

This line is from the forty-sixth case of the *Blue Cliff Record*.

Master Kyōsei asked a monk, "What is that sound outside the gate?" The monk answered, "The sound of raindrops." Kyōsei, aggrieved by the monk's answer, responded, "Sentient beings are inverted. They lose themselves and follow after things."

That which hears the raindrop and that which is being heard are not two separate things. There is no enlightenment in saying, "The sound of raindrops." As long as we think there is an "I" listening to some thing that is not-I, we're being moved about by those thoughts. When we hold on to nothing, we become the sound of the raindrops. The raindrops become us, and we fill the heavens and the earth with their sound.

We sit zazen and cut off thoughts until we have gone beyond life and death and know freedom from desire. But can we sustain that state of mind during our daily life? Can we hold on to nothing in the very midst of using all of our senses?

As long as the listener and the raindrop are two separate things, there is a "me." When no speck of "me" remains, we know "the sound of raindrops." This state of mind is the awareness of the raindrops themselves—drip drip drip—falling within the body. If we try to understand or explain it, we fall into dualism. This is why all that can be said is "drip drip drip, I am falling." Unless we realize this sound of rain that fills the heavens and the earth, we will never know true joy.

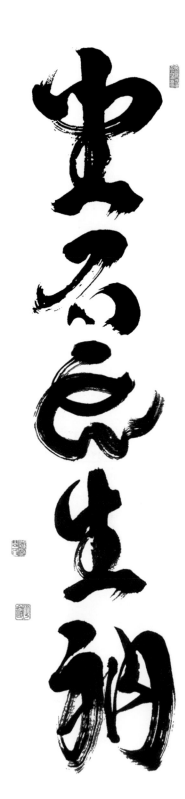

坐石雲生衲

This line is from the Cold Mountain poems of Kanzan.

I am sitting alone on a crag, looking at the clouds billowing all around me. The clouds obscure my view in every direction, yet the mind within is wide open, bright, clear, and revealed fully in all the ten directions. I am here, having chosen the wisdom of life. The heavens and earth and I are one, and all the ten thousand things and I share the same root. Not a single one of the ten thousand things exists apart from my subjective perception. I form one whole with the entire universe. The universe is eternal and I am eternal. There is no birth or death here. If we realize this endless source of Self, then the clouds become a robe for the body.

From the profoundest depths of the valley, the mist rises, wrapping my body like a robe. The dew of the pines dampens my robe's sleeves. At noon the sun decorates my body; at night the moon adorns my head. The heavens, the earth, the universe, all together, are me.

We have been born to experience this expansive, enormous world. We are alive not for the sake of acquiring trivial worldly possessions or fame—these are all phenomena that last only while we are alive. To seek the awakening of all beings, to experience the deepest source within the mind of each of us, isn't that what life is for?

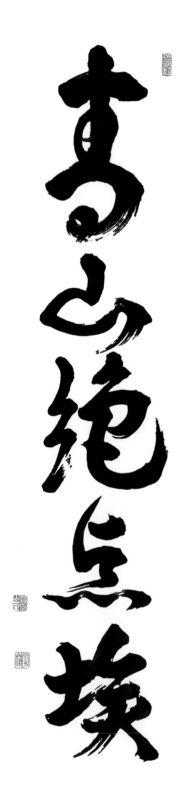

青山絶点埃

Seizan ten'ai o zessu

On the green mountain, not a speck of dust

It's easy to spend our entire lives as if behind a veil. But when we can't see our inner land-scape, the world lacks clarity and brightness. We have to be able to know our deep mind and let go of cluttered thinking; only then can we touch our own true Source. For this we struggle and make effort.

When our mind's eye opens, it's as if we're seeing for the first time. Suddenly, all of the ten thousand things are clear—the mountains, the grasses, the trees, and the flowers are all enlightened together. When we forget our hate and resentment and our unkind thoughts and see everything through clear and bright eyes, forgetting others' faults and our own failures, we receive everything with warm compassion, and living is so easy and comfortable!

"On the green mountain, not a speck of dust" is not the scenery over there somewhere. When our mind's eye is open, we become this state of mind as a matter of course. We remain fresh every day, living each day with new wonder. That is a *true* religious life.

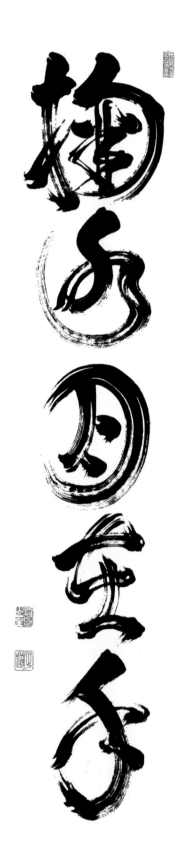

掬水月在手

Mizu o kiku sureba, tsuki te ni ari
I scoop up water and the moon is in my hands

This line, from the records of Master Kidō, is a couplet with "I play with flowers and their fragrance clings to my clothes."

When we scoop water into our hands and allow it to become still, the bright moon is reflected back to us, just as it shines in the sky above. Everything else is reflected as well—a child, an elderly person, a bird, a flower—settling right into our own hands. Likewise, when our mind is like a mirror, with no separation between self and other, we can express ourselves with clarity and simplicity. This is a very mysterious state of mind. Pure clear Mind is the Buddha's wisdom.

We are more than our physical bodies. We have feelings that can become perfectly matched with the feelings of another. With this Mind we can know another's deepest joy and wisdom as our own, and we can know another's suffering as well. This functioning is called the compassion of the Buddha.

While we all are endowed with this Original Nature, we are not all able to live in this way because our minds are filled with impurities. For this reason the Buddha taught that first we must quiet our mind. When our mind is still, it becomes pure on its own. The extraneous noise diminishes, and the moon shining in the sky and the moon in our hands become one and the same moon, matched perfectly. To clarify the mind, doing no harm while giving life to all that is good—there is nothing more essential than this in the teachings of the Buddha.

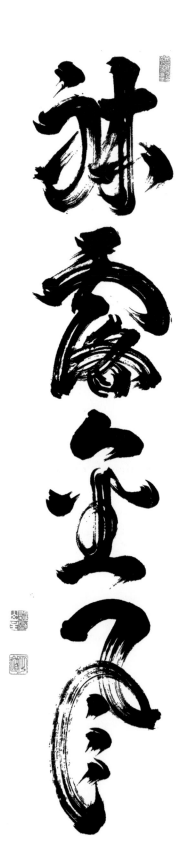

躰露金風

Tairo kinpū
Manifest completely the golden wind

This phrase is from the twenty-seventh case of the *Blue Cliff Record*. A monk asked Master Unmon Bunne, "How is it when the tree withers and the leaves fall?" His question was about not only nature but also our state of mind when we are no longer thinking about this and that, when the problems of life and death are no longer a consideration, when there is no longer any distinction between an ignorant person and a Buddha.

Master Unmon answered without hesitation, "Manifest completely the golden wind!" The golden wind is the autumn wind that crosses the skies as the crops ripen and bear fruit. The monk, having reached a state of zazen free from any extraneous thoughts, came to Unmon with a withered, wintry mind, and to this monk Unmon replied with a ripened, abundant state of mind. Now, expand throughout the whole world and throughout the heavens!

The monk knew the serene and clear state of mind that is the source point for ending the suffering of those in society, but if he remained at that source point, how would he be able to liberate others? The ultimate point of zazen is to do it from the very top of the head to the very bottoms of the feet, completely and totally, with every cell and pore. When our state of mind is so full and taut that it reaches every corner of our being, with this body we know the fullness of the universe. Fresh and new, we create a new world and give life to all things. If any delusion or confusion remains, or if thoughts about something else arise, the essence is diluted. If we have any self-consciousness, our zazen does not blossom.

For our mind to open, we have to realize that absolute possibility and freedom and love of all people. Where in life is there happiness or good fortune other than this?

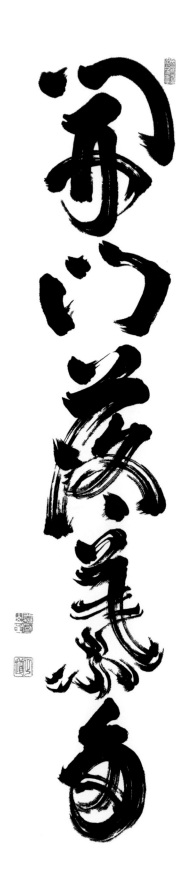

開門落葉多

Mon o hirakeba rakuyō ōshi
When I opened the doors, there were many fallen leaves

This line forms a couplet with "Listening to the rain, I passed the cold night hours." After listening all night to the lonely sound of the rain, the poet found, upon opening the door in the morning, that he had in fact been listening to falling leaves hitting the edge of the eaves.

Ryōkan wrote, "The wind has brought enough fallen leaves to make a fire." This was Ryōkan's description of his state of mind when he lived in Gogo-an hermitage. Living in oneness with nature, he found many uses for the fallen leaves in his daily tasks.

Today we are surrounded by every possible tool. We are flooded with possibilities and drowning in dissatisfaction. The simple and plain way of life of Ryōkan is no longer common. Rather than wanting more, we need the wisdom to make do with what we already have. Instead of filling the mind with the clutter of our thoughts, we need to cultivate its quiet spaciousness.

But even for Ryōkan this world of knowing what is sufficient was not readily apparent. Seeking a cure for his heart's deep problems, he ordained. But the world of ordination could not satisfy his artistic mind, and he threw that away as well. Finally, making his home in the mountain hermitage, he was able to let go of desires and attachments, let go of ideas of a world of enlightenment. While keeping his vow to liberate those who suffered, he knew the spaciousness that comes with throwing away self-indulgence.

When we stop looking for someone or something new and different, we can be in that place of abundance and quiet no matter what might come along. This is the meaning of "When I opened the doors, there were many fallen leaves."

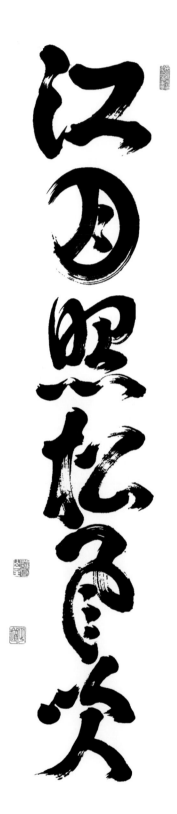

江月照松風吹

江月照松風吹

Kōgetsu terashi shōfū fuku
The moon gleams on the water, wind blows through the pines

These words are from Yōka Genkaku's "Song of Enlightenment." It is our nature to be at one with the heavens and the earth, not stuck on anything. To awaken to this all-embracing Mind, we have to decide that we won't give our attention to the manners and customs of the world; instead, we will be like the chill moon of autumn shining with great radiance.

Instead of thinking about yesterday or tomorrow, we sit zazen, becoming that one person who fills the heavens and the earth. There is only that bright moon shining in the sky. Does the moon in the sky shine us, or are we the moon in the sky, shining? We can't tell the difference. When we experience this, for the first time we know the truth of being human. Our body melts into space, and our mind is like a bottomless lake in which we find endless serenity. Time is no longer a concept. We experience the eternal now.

When we open our mind and receive the heavens and the earth, we will know for ourselves the state of mind of the Buddha. We will know the source of all existence, and that we are one Truth with the entire universe. The form of the universe changes constantly, but we know its essence and know that it is eternal, and so are we. Death and birth don't exist there. In this very body that decays, we experience eternal life.

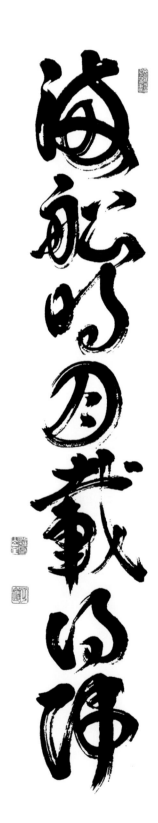

海路吟

海路吟明月載归帆

満船明月載得帰

Mansen no meigetsu nose'ete kaeru
I fill my boat with moonlight and go home

This is the second line of a couplet, following "Still night, cold waters, no fish are biting."

These lines express a state of mind of complete awakening. The bright, full moon shines down from above. Forgetting the fishing line, forgetting the body, we are absorbed into this light, but this light is not the moon in the sky, it is the moon of each of us. All of the universe is one bright light.

When we don't call even one thing our own, we have no fear of losing anything. We forget our body, and the whole great universe is our home. In our minds there are no thoughts to be caught on, no clouds, no problems. While it is human to not want to die, if we resist death we know even greater fear and terror. Money is convenient and useful, but we can live without it. If we think we need lots of money, we become its slave. If we are caught on fame and knowledge, we end up in conflict with other people and are never free from our fears about what others think.

To liberate ourselves from every speck of fear, we have to know that abundant, huge, wide-open Mind. Then we can see the world. We will encounter sickness, calamity, and death. Those are the real things of life. But when we receive it all naturally, our fear is resolved.

Not one fish has been caught, but the boat is full of moonlight and we lightly row it home. To know this state of mind is the highest joy. No matter where we are in our life, we are able to bring forth infinite wisdom and share it with others, and this is where the Truth is manifested.

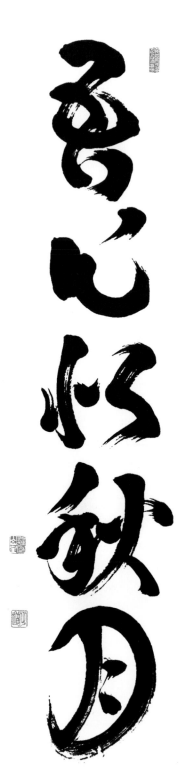

吾心似秋月

This line is from the Cold Mountain poems of Kanzan:

> My mind is like the autumn moon
> clear and bright in a pool of jade

As we look at the bright autumn moon, we know completely that place of no separation between self and other, where the world and the self are born simultaneously and without division. The moon is the light of our mind, and the light of our mind is the light of the moon, illuminating the heavens and the earth.

When we taste the flavor of this completely serene state, we understand Zen from our own experience. The heavens and the earth, exactly as they are, become our body. We remain a self but are simultaneously one with the One Truth of the whole universe. Even though the external world is always in flux, our awareness is like a camera lens, or a mirror, which receives anything and everything, as it is, in its entirety. This awareness without any discrimination whatsoever is the pure awareness with which we are born. Here there is no dust on the mirror; here the lens is not clouded at all.

When Master Rinzai described the Dharma as having no form yet extending into the ten directions, he was talking about this infinite deep Silence, the source of our mind. This is what Kanzan is talking about as well. We become one with the whole world with its infinite light and potential. From here our radiance is born infinitely.

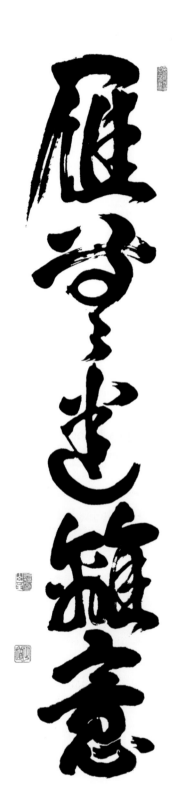

雁引遠随意

雁無迷離意

Kari ni meiri no i nashi
The geese know no confusion

This phrase is a couplet with "Water does not intend to reflect shadows."

In Japan it's common to see geese flying across the evening sky of autumn, in perfect harmony. In autumn the geese fly south to avoid the oncoming cold, and with the warmth of spring they return. This migration is not blind, unnecessary movement but a natural means of survival.

When water is calm and clear, without fail the moon in the sky will be reflected there. Whether the water is that of a pond, a lake, an ocean, or a puddle, if it is still, the moon is reflected. Yet the water has no intention of reflecting something. The same is true of the Mind that each and every one of us has at birth. Like a mirror, that Mind reflects just what comes before it. There is no intention there. Each thing is manifested just as it is, and after it departs, nothing is left behind.

Even though we are already being shaped by our heredity while in the womb, when we are born our essence remains pure. Immediately after birth we're touched by endless external stimuli that are absorbed and stored in our memory. From sixteen months of age, we are able to perceive "one." At twenty-three months we understand "two." With awareness of the self as separate, awareness of good and bad arises as well. It is said that our mind as it is cultivated in our first three years is the mind with which we live for one hundred years. From here begins our deep struggle to obtain what is best for ourself, to improve our position while pushing others down. Living with this two-edged sword is a challenge of being human.

We cannot throw our ego away completely, but we can decline ownership of it. To awaken to our origin prior to ego is the subtle flavor of zazen. As our body and mind become quiet, we can receive this world as it actually is. No matter how awkward or slow someone is, if that person does zazen and realizes that world of one, he or she can see things exactly as they are, as one living whole truth. While being in the world, to forget ourselves completely and become one being with another person: this is our true original quality.

落霞與孤鶩齊飛
秋水共長天一色 *(overleaf)*

Rakka to koboku to hitoshiku tobi
Shūsui chōten tomo ni isshiki

In the sunset haze, a lone goose on the wing
Autumn waters one color with the endless sky

Hakuin used these phrases to express the emptiness described in the Heart Sutra. The clouds are tendrils in the deep, clear, expansive blue of the autumn sky. In that same oneness there is also a deep, blue body of water, the water of autumn. Through the wide-open, all-embracing, boundless blue sky, the autumn breeze blows briskly, filling everything abundantly. This is the state of mind of prajna wisdom. Anyone can awaken to it.

If we become the state of mind of the wide-open autumn sky, it does not mean there is nothing there. To have is to not have, and to not have is to have. Form as it is, is emptiness; emptiness, as it is, is form. To hold on to nothing at all means that we can receive everything. No matter what happens, we are not obstructed. As Rinzai says, "There is nothing that comes to me that is liked nor disliked." This is the world of "Autumn waters one color with the endless sky." A lone goose is joyfully flying through the lines of mist at sunset. This is "gyate gyate paragyate parasam gyate bodhi svaha."

In the 270 words of the Heart Sutra, this phrase at the end, chanted in its original language rather than in Chinese or Japanese or English, is the central message. We chant these words wholeheartedly as they are and go beyond delusion, not thinking of a meaning and letting go of any negativity. In this way we know a positive, high-quality state of mind and bring forth the merit that is in the words. If we made an attempt at translating them, it would be, "Arrived, arrived! Arrived on the other shore!" We have realized enlightenment. "Realized! Realized! Completely realized!" Just as we are, that is fine!

If we chant these last words with our whole being, sweating with our whole body and becoming the words completely, we forget our body; in chanting them tens of times, hundreds of times, we forget time, and then we know deep wonder and amazement. Our tears

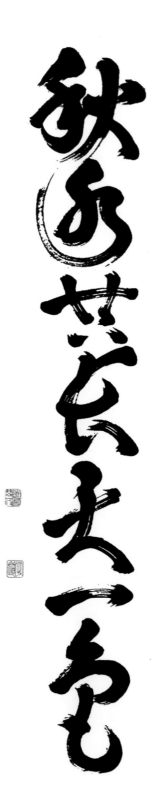

秋気共長天一色

fall and we can teach the Dharma. People of old taught this, and it's true. We become this state of mind like the huge, wide-open autumn sky. We know that state of mind when we forget our whole body and all of our thoughts, when we forget ourselves completely.

When we can forget ourselves completely, for the first time we can become the state of mind of others and work for them. That is our greatest good fortune in the world. These phrases are telling of the experience of this state of mind.

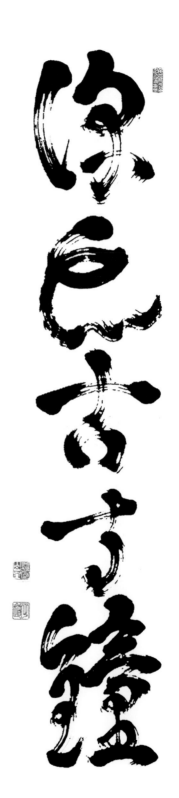
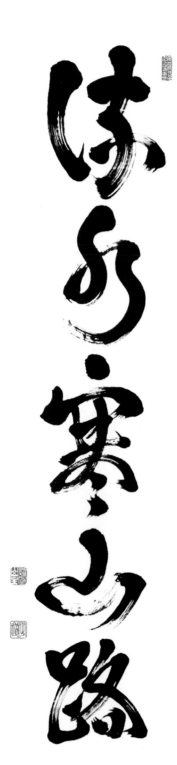

流水寒山路
深雲古寺鐘

Ryūsui kanzan no michi
Jin'un koji no kane

A running stream, the cold mountain path
Deep in the clouds, the old temple bell

If we seek the place where we can drop body and mind and be free from all the difficulties and pains of life, we can find it in this cold mountain. But this cold mountain is not located in some remote area. It exists within each of us. As we leave the busy world behind and climb up the mountain, we reach a spot where thick moss covers everything, its green-blue color penetrating our eyes. Alongside the flowing stream, many trees grow.

This area of the cold mountain is deeply quiet. No sounds of traffic can reach here, and not one word is spoken. The voice of the pines is spoken by the wind. We wonder if there are others who would like to leave the turbulent world and who could also deeply enjoy this state of mind of the cold mountain.

When we hear the sound of the bell ringing from the far temple we forget all time and space and experience boundless eternity. With the sound of the bell we leave behind the world, realizing serene nirvana, where there is originally not one single thing, where all things are from the origin free from greed, ignorance, and anger.

This is the ringing of Mind, but we don't hear it with our ears. Only when we forget our body, forget the entire world, can this sound resonate for the first time.

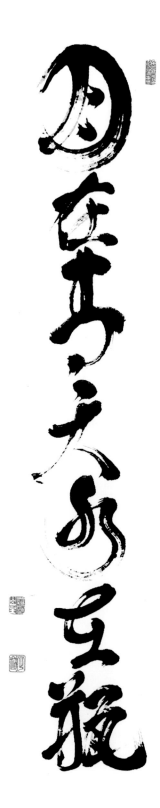

月在青天水在瓶

Tsuki wa seiten ni ari, mizu wa hei ni ari
The moon is in the blue sky, the water is in the bottle

Hakuin's *Kaian Kokugo* tells of Daitō Kokushi's teaching on the Buddha's birthday. With one hand pointing to the heavens and the other pointing to the earth, he announced that there is only One. Pointing at the heavens, he asked, "What is there? The moon is in the blue sky!" Pointing at the earth, he asked, "What is there? The water is in the bottle."

But as always, everyone looked at the phenomena and neglected the actuality. We offer thanks to some golden Buddha, but our truth is not the Buddha's form! It is our clear Mind, which can't be spoken about and can't be decorated. We pour sweet tea over the statue of the Buddha on his birthday, but how can we pour tea over a thing that has no form? With his whisk Daitō hit the table loudly as if to say, "Don't look away from *It*!"

The Buddha said, "In heaven and earth, there is only one person." There's no such thing as a god in the heavens to save people and or a devil on earth to punish them. Yet people interpret the Buddha's words in that way. Regardless of the interpretation, there's no truth of the Buddhadharma in the words themselves! People always add in aspects of their own ego; rather than experiencing the moon, they start trying to understand and explain it. In the state of mind of "The moon is in the blue sky, the water is in the bottle," there is no blue sky and no bottle, no moon and no water.

When the Buddha said, "In heaven and earth, there is only one person," pointing a finger to the sky and a finger to the earth, his meaning was not in his gestures. But the more we explain the further away we get. When we hold on to not one thing and say nothing, then we can receive the moon and the bottle clearly.

山茶不及秋菊妍

山花開似錦
潤水湛如藍 *(overleaf)*

Sanka hiraite nishiki ni nitari
Kansui tataete ai no gotoshi

Mountain flowers bloom like brocade
The valley streams brim indigo blue

This couplet comes from the eighty-second case of the *Blue Cliff Record*.

Master Dairyo Chiko Kosai was of Tokusan's lineage, but little more than that is known about his life. In this case, a monk asks him, "The physical body rots away: what is the hard and fast body of reality?"

Our physical body will without fail lose its breath and its pulse. If taken to the crematory, it become ashes. If buried, it becomes worm food. Everything is impermanent; without fail everyone dies. Those who meet part; whatever is built crumbles. Feeling this impermanence, we long for the eternal.

This longing is what led the Buddha to leave home. For six years he trained in the mountains, and then he experienced that which is without birth and without death. He awakened to the eternal life energy. Each and every one of us has to discover this eternal life within our own rotting flesh. That is the truth of the Buddhadharma.

The monk asked, "The physical body rots away: what is the hard and fast body of reality?" That eternal life energy, that which is not born and does not die, that to which the Buddha awakened—where is it? Did this monk already know? Was he asking his question to test Dairyo? If he asked without knowing, then he was still confused about where he himself was headed. If he knew and still asked, he was falling into the trap of dualism and relativity. He was still looking for something special within himself, and anything that he understood was only mental dross and not yet born from experience.

Dairyo replied without hesitation, "Mountain flowers bloom like brocade. The valley streams brim indigo blue." The cherry trees are blooming. The mountains are a rich brocade, a gloriously complete world. This is the pure body of the Dharma. The stream is so full that the water appears not to move. This is the eternal world of our wide-open awareness. We want the blossoms to last forever, but in three days they are gone. They fall with

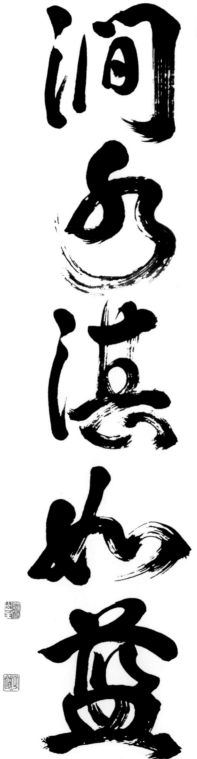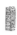

the rain. With one gust of wind, no trace remains. At the stream's edge the water seems still, but it's always flowing, always changing. Yet in the constantly flowing water we can find that world that does not flow at all. The cherry flowers all of a sudden fall away, but in an instant we discover a world that does not change.

This body of ours will die and be gone, but within it exists an eternal form. In our own body we can find the pure body of the Dharma, the absolute that drinks down the whole universe. There's no eternal separate from the temporary. There's no absolute separate from the individual.

Dairyo offered no such intellectualization or explanation. He simply spoke about the world exactly as it is. In that way, he highlighted the monk's weakness. But this monk probably didn't understand. He was looking for something apart from the physical body, something to hold on to! We all think we need that! But Master Dairyo smashed the concept of a precious soul.

If we have had the same experience as the Buddha and the Ancestors, then we have been liberated from any dependence on the Dharma and the Buddha. We know Dairyo's free and easy state of mind because it's ours. It's the responsibility of such a person to crush the delusions of a person of training, and this is what Master Dairyo did.

碧漂清皎涼

碧潭清皎潔

Hekitan kiyoku shite kōketsu tari
Clear and bright in a pool of jade

This line is from Kanzan's Cold Mountain poems:

> My mind is like the autumn moon
> clear and bright in a pool of jade
> nothing can compare
> what more can I say

Our minds are filled with thoughts about our past experiences and feelings. The weight of this accumulation presses on our awareness, obstructing our mind's natural clarity and distorting our perceptions.

The Buddha divided awareness into eight strata. The functioning of our five senses is the fifth stratum of awareness. The roots that precede those senses form the sixth. The seventh connects the functioning of our senses with the roots, while the eighth is the collective awareness. The various types of awareness are all set into action by the sixth stratum, which gives the orders, which are then organized by the seventh stratum. But the seventh consciousness is what so often leads us into mistakes of perception, under the influence of ego and personal preferences.

The fifth through the eighth strata can all be clarified with zazen and purified with the light of kenshō. When we do zazen, through our senses we receive the wisdom of seeing all equally; through the sixth stratum we experience the miraculous clear bright mirror wisdom; in the seventh we find the wisdom that doesn't discriminate but sees all people and worlds as equal and beyond self and other; while in the eighth the wisdom of our clear, bright, open, mirrorlike Mind is made transparent. As Hakuin said, in the clear blue sky of samadhi we experience this fourfold wisdom.

When we realize this clear Mind, the functioning of the Buddha is born. There is nothing in the Buddhadharma but this.

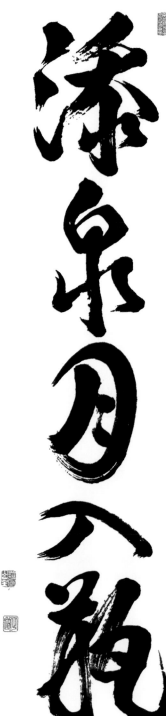

漆泉月入瓶

添泉月入瓶

In Zen we look at the self and the world as one and the same, a united whole. Do flowers exist because we see them, or do we see flowers because they exist? Even though we try, we cannot divide the subjective from the objective.

When the subject and the object become one and the same, this is the experience of realization. When we move in oneness with the heavens and the earth, this is the experience of Zen.

We see the flowers and the mountains, we hear the bell ringing, and we know it all as ourself. The river is ourself, and so is the other. We see that from the origin we are all one and the same. This experience is Zen.

The moon in the deep spring is so beautiful that we are pulled right into it, and that moon itself is in a vessel that becomes the moon's very purity and clarity. The moon is me, and I am the moon. We enjoy this world completely.

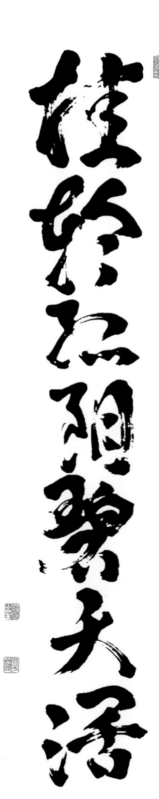

住於孤頂碧天活

桂輪孤朗碧天濶

The Mind with which we are born is infinite in its spaciousness, shining eternally like the full moon of autumn. Although the ego arrives with its habits and prescriptions, Original Mind remains unlimited. To realize this is satori, and to believe in it deeply is to be a person of true faith.

With a wide-open abundant state of mind, we forget our own concerns and seek only others' good fortune and joy. While our eyes themselves are tiny, we can see the entire universe through them. We realize that since everything can enter into us, we are everything. When we know this place where nothing separates self and other, we know the wisdom of the Buddha. The moon, bright in the heavens, is this world of complete oneness of subjective and objective.

When we are one with the world, we can do nothing other than love the whole world completely. Thinking that "my life is for me" is not the way of Buddhism. But so often people live to satisfy only their own hunger. This is so sad and miserable! If even one person can know the true joy of being alive, the difference is immense for everyone who comes into contact with that person. Yet we cannot look only at what is good for the whole and ignore the individual. Each person's splendidness has to be recognized and acknowledged. When the whole recognizes each and every individual, our life is for the first time healthy.

When we know our mutual mind without any attachments, no matter what might happen we can receive all of it. If we're criticized we don't resent it, and if we're successful we don't become conceited. No matter what comes our way, we are not moved around. This huge abundant spaciousness is Buddha Nature's great strength. A warm love for everything comes forth spontaneously, and this way of being a human is clear and eternal.

明月苍苍君自香

明月蘆花君自看

Meigetsu roka kimi mizukara miyo
You must see for yourself the reed flowers in moonlight

This phrase is from Setchō's poem to the sixty-second case of the *Blue Cliff Record*, in which Unmon says, "Within heaven and earth, through space and time, there is a jewel, hidden inside the mountain of form. Pick up a lamp and go into the Buddha hall, take the mountain gate, and bring it on the lamp."

Taking the stone lantern into the large hall is easy, but putting the mountain gate on top of the lantern goes against our notion of reality. Our usual way of thinking has to be cast off. Our life energy has to become the mountain gate and the stone lantern, and our zazen must become the Buddha hall. Unmon is not talking about the shapes and forms and what differentiates them. It is irrelevant whether the mountain gate is the mountain gate, the Buddha hall, or a stone lantern. When we know the Mind beyond such discriminations, the Buddha hall is not large and the stone lantern is not small. This huge boundless world is felt, right here inside us. Within the infinite sky, within the eternity of time, there is but one truth, and this one truth is the jewel within this physical body.

The whiteness of the reed flowers is exquisite, and the moonlight of September is also brilliantly white. They are different, yet they exist in one and the same actuality and are of the same essence. Is the moon shining on the reeds, or are the reeds reflecting the moonlight?

When we see the whole universe everywhere, we know that the Buddha hall, the stone lantern, and the mountain gate are all melted into one. Setchō is offering us this huge wide-open space.

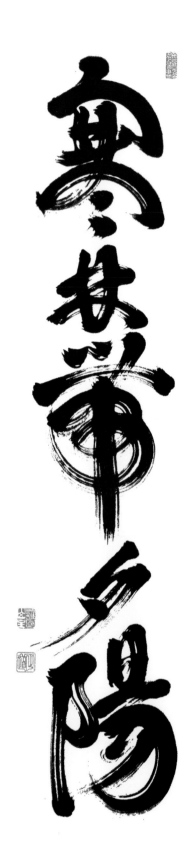

寒林帶夕陽

Kanrin sekiyō o obiru

Afternoon sun embraces the winter woods

In Japan in the early spring, the dogwoods and wild magnolias bloom white on the mountainsides. Eventually the mountains are ablaze with purple azaleas and pale pink cherry blossoms. As the flowers begin to fall, the young leaves turn a deeper green and wisteria flowers drape from the highest branches. As the plums and the peaches and the cherries bloom, the meadowlark raises its voice. Then, in the strong sunlight of early summer, the cicadas, holding precious their brief lifespan, sing their dream. In the heat of summer the west wind blows, and then the colors of nature begin to tint into a gorgeous brocade.

The ever-changing mountain scenery brings the bright mountains of the moonlit night, the fresh mountains of dawn, the severe mountains of the windblown rain, but none match the deep essence of the winter woods, pure with naked branches. The pale light that crosses the forest bathes the far mountains in its dimness.

The poet Fujiwara Teika wrote: "Wherever one looks there are no more colored maple leaves or flowers, only the small hut in the autumn twilight." This is the serene Mind of nirvana. Here desires and extraneous thinking have been cut away completely. When we actually taste this state of mind, for the first time we know from our own experience that "this very place is the land of lotuses and this very body is the body of the Buddha."

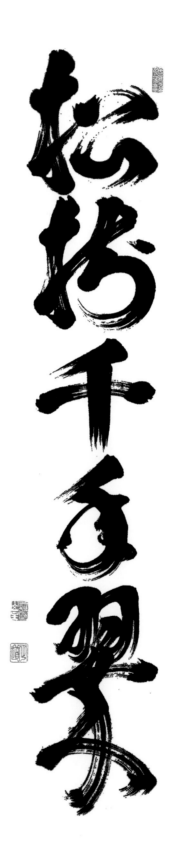

松樹千年翠

Shōju sennen no midori

The pine tree, a thousand years of green

Because the pine remains green throughout the year, it has become a symbol for success. But even though the tree remains green, its needles are constantly dying and being replaced. There is no aspect of the world that does not change. As Prince Shōtoku said, "The world is always in flux, filled with transient appearances." Within constant change, we must realize a state of mind that does not change. Only then can we see beyond change. To be in the world of life and death and yet realize that which is beyond life and death is to realize the Mind of the Buddha.

旋雪運天風

臘雪連天白

Rōsetsu ten ni tsuranatte shiroku

The year-end snows fill the skies with white

This phrase is from Hakuin's *Kaian Kokugo.*

When he was twenty-nine, Hakuin trained at Inryo-ji temple. Doing late-night zazen, he listened to the falling snow and became so deeply absorbed into its serenity that all he could perceive was a world of solid white, without a single detail. In this state of mind, all extraneous thoughts are gone, and no one remains to hear the sound of the snow. As the snow piles up higher and higher, we are one and the same with the scenery; our eyes and ears are completely purified, with nothing intruding. The swoosh swoosh of the falling snow has become a sound without sound.

We have to taste this flavor at least once, or we cannot speak about Zen. We must come to know this place where everything is extinguished, where even the idea of the possibility of a world is gone, where there is only white snow piling higher and higher. But if we remain in that world, without any thoughts, we will surely be stuck there our entire life.

"Coming out from behind the cloud, I am this winter moon. The wind stings my body; the snow is freezing cold." These are the words of the monk-poet Myōe Shonin, describing the countryside near Kyoto. As he walks carefully back from the zendō on a snowy evening, the moon comes from behind the clouds, and he doesn't know if it is the moon that is protecting him on the snowy evening or if it is the moon walking down the path. A wolf cries, and it's okay, the moon is there too; its light is everywhere, the moon and his mind complete in oneness.

Where the world of nature and I are one mind—where the world and this warm love are melted into one—this is Zen.

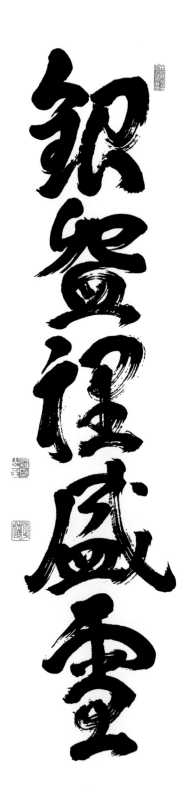

银盆征盛雪

銀盌裏盛雪

Ginwanri ni yuki o moru

Piling snow into a silver bowl

In the thirteenth case of the *Blue Cliff Record*, a monk asks Master Haryō, "What is the Daiba school?" Haryō answers, "Piling snow into a silver bowl."

Master Daiba, the Fifteenth Ancestor, received transmission from Master Ryuju. Also known as Nagarjuna, Ryuju was famous for having kept the teaching pure and its essence clear. He was abundant in his expression yet very subtle in its manifestation. Most attempts at putting the ultimate into words result only in lifeless explanation, but Daiba kept Ryuju's essence alive, avoiding verbal pitfalls. The most important point in his teaching wasn't the words, it was awakening to *THIS*.

Into a newly made, shining silver bowl, freshly fallen pure-white snow is piled high. This freshness is the Daiba sect, zazen, and Haryō's state of mind. Both the Ancestors' state of mind and the Buddha's teachings have been pierced through. Subject and object, the world that is seen and the one who is seeing it, have become one.

The true liberation of all beings can happen only when we are without any idea of helping at all. When we go into the world with that state of mind, for the first time we can truly function. This is what is most necessary in society today. When we function without force or attachment in our relations, we have the power to bring forth each other's deepest state of mind.

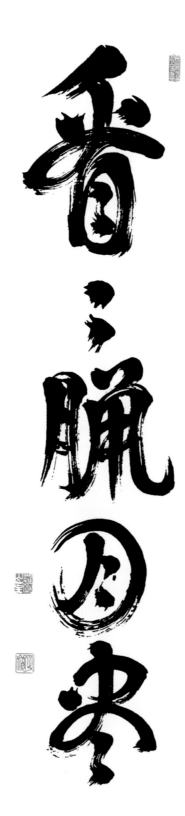

看看臘月盡

Miyo miyo rōgetsu tsuku
Look, look, the year draws to an end!

This line is also from the records of Master Kidō.

At the end of the year, we do a huge cleaning in which we sweep behind even the dressers and bookcases, clearing out all the dust that has collected during the year. Although the individual particles are unnoticeable, dust accumulates in astonishing amounts. Throughout the year we have also collected piles of books and magazines. We think we will read them, but before we know it the year's passed and we haven't looked at them, and we have no place to put them either.

Isn't our mind like this as well? In Buddhism we call the world of our mind the storehouse of consciousness. This storehouse contains not just our own experiences and knowledge, but the experiences of our parents and our ancestors as well. We have access to infinite experience and knowledge and memory, but there is much of which we are unaware, a vast darkness from which our delusions and desires exude like gas. We are, as an ego, nothing more than a conglomeration of past memories and this dark ignorance.

In society there is always conflict because people act according to their own opinions. Yet differences of opinion, from those between parents and children to those between nations, are not about human versus human but rather about memory versus memory, experience versus experience, history versus history. We say, "That person is awful," but it is not the other person that is bad. It is the memory of what the person said that is bad, like something pasted in an album. We allow memories of the past to influence our present, and this is a source of great confusion.

At the end of the year, let's clean not just our rooms but our minds as well, straightening up our thinking and ideas, sweeping away clutter and welcoming the new year with a mind that is fresh and clear.

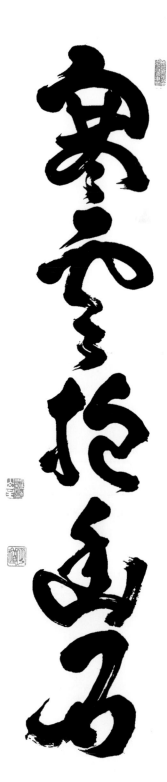

寒雲抱幽石
霜月照清池 *(overleaf)*

Kan'un yūseki o idaki
Sōgetsu seichi o terasu

Cold clouds embrace lonely rocks
The frosty moon shines upon the clear pond

These lines are from Hakuin's *Kaian Kokugo*.

Master Hyakujō Ekai asked Nansen, "Was there something that the Buddha and all of the Ancestors could not express?" This is a tough question. The Buddha's truth must be realized through experience, yet as soon as the experience is spoken of, it is no longer pure experience. When the Buddha was dying, he said that even though he had taught for forty-nine years, he had never taught a single word. His words were gathered in 5,049 sutras, but they still don't express it. So what is it?

Nansen answered, "There is."

Hyakujō asked further, "Then what is that which cannot be spoken?"

Nansen responded, "It is not mind, it is not Buddha, it is not a thing." Here is the experience expressed exactly as it is. That which surges and fills the great heavens and the great earth is not mind, not a physical body, and not a mental understanding, only the thing exactly as it is.

Hyakujō said, "There! It is said!" He understood and heard those words clearly.

Nansen continued, "Whether it was said or not, I don't know. Only this!" That unmoved essence, the experience exactly as is, is what must be seen here. Then Nansen asked Hyakujō, "How about you?"

Hyakujō answered, "I have no such great wisdom as those historical Ancestors, to say it or not say it. I don't know about anything as difficult as that." Although Hyakujō was using words, the experience that is absorbed into those words, manifested exactly, is what has to be seen here. It may look as if he's running away, but he's not. He is expressing what is beyond words, saying what cannot be put into words.

Nansen dug in further: "What do you mean? I don't understand." He was not saying that he didn't know the essence itself; rather, he was experiencing the essence that cannot

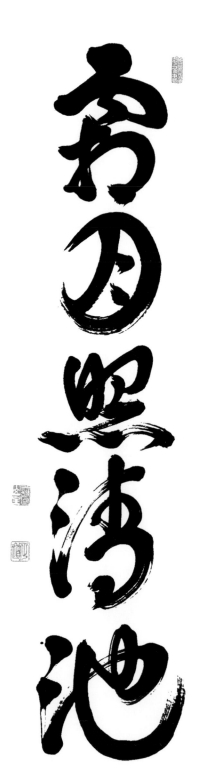

be expressed and responding to the words of Hyakujō. Both Hyakujō and Nansen knew completely, yet they said they don't know at all.

Finally Hyakujō responded, "It seems like I have talked too much." This is the truth that cannot be spoken, that which is taught without being taught. While one who knows this experience can't describe it, the experience is manifested in the speaking of the words. Can the truth of deep Mind be spoken or not? Those who have experienced it can perceive it, while those who haven't cannot. When we have realized the marrow of Zen, in everything we know a deepening of the ultimate realization, while at the same time we do everything possible to liberate all people.

"Cold clouds embrace the wondrous rock" is this state of mind. "The frosty moon shines on the clear pond" is the state of mind of Hyakujō Ekai. To know the profound truth of Nansen and Hyakujō we have to become those cold clouds and that wondrous rock. We have to become that frosty moon, reflected in that pure clear water. If you try to understand it with words and ideas, the experience is impossible to realize.

聖蔭剎寧陽生

群蔭剥塵一陽生

Gun'in hakujin shite ichiyō shōzu
With yin fully exhausted, yang begins to appear

This line, from the *Katai Futōroku*, perfectly expresses the winter solstice. In far northern countries, the sun appears in the December sky for only a short time each day. People living there wait for the completion of the yin, the darkest part of the year, and for the return of the yang, when minutes of daylight increase each day.

In Buddhism, when desires are extinguished, it is also a case of "with yin fully exhausted, yang begins to appear." When we act based on our egos, our desires spread infinitely in every direction. In our hearts we are greedy and grumbling, ignorant and blind; in our minds we create our own misery with nonstop thoughts. When those desires and attachments are over and done with, how refreshing and clear everything is!

On the eighth of December the Buddha saw the morning star and said, "How wondrous! How wondrous! All beings from the origin are endowed with this same bright clear Mind to which I have just awakened!" Just as he realized that the whole universe is our body, we too can know the wonder and amazement of this huge, all-embracing self. It is our responsibility as humans to open this eye of wisdom.

The Rōhatsu ōsesshin culminates on December 8, in accordance to the deep awakening of the Buddha. For the Dharma to be kept alive, people of training go beyond the hardships and struggles of this sesshin and, when it is finished, celebrate the winter solstice, offering gratitude for all that we receive so abundantly from nature.

Following the solstice, the lengthening days of winter will lead to spring. Our mind's spring also must come, or we will not fulfill our value as humans.

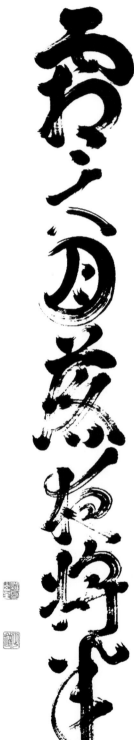

霜天月落夜将半
誰共澄潭照影寒 *(overleaf)*

Sōten tsuki ochite ya masa ni nakaba naran to su
Dare to tomoni ka chōtan kage wo terashite samuki

The moon is setting in the frosty sky, it's almost midnight
With whom can I share these winter images caught in the still pond?

These lines are from Setchō's poem to the fortieth case of the *Blue Cliff Record*.

> Hearing, seeing, understanding, knowing, each of these is not separate.
> For him mountains and rivers do not appear in a mirror.
> The moon is setting in the frosty sky, it's almost midnight.
> With whom can I share these winter images caught in the still pond?

This is not something to be understood conceptually. When we see, we see with our whole body. When we hear, our entire body is our ear. In this way, we become one with what we are seeing and hearing. When we add a mental understanding it creates a gap between subject and object. When nothing is inserted between that which is seeing and that which is being seen, we know the actuality of life's energy.

On a chilly winter night when the frost has settled and the moon has set, everything becomes darker and darker. Is it me becoming the darkness or the darkness becoming me and extinguishing the light? If I look for my body, it can't be found. The wind doesn't stir. Water fills the pond to the brim. There's a slight reflection of the mountain, but it's impossible to tell where the mountain ends and the pond begins. There is no distinction between perceiver and perceived. Everything is melted in oneness.

One day while Nansen was cutting weeds, a monk asked him, "What is the Path of Nansen?" Nansen thrust out the tool he was using and said he had bought it for thirty cents. The monk was astonished. He had asked for the truth, and he received the price of the master's cutting tool. The monk continued, "I'm not asking about your tools but about the truth of the Path." Nansen responded, "I have used it, and it cuts well!" Ignoring the monk, he went back to work.

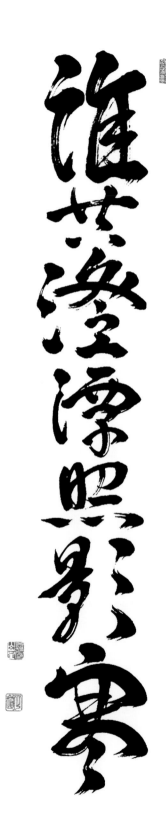

淮岸澄漂照影寒

This monk thought that our mind contains some special thing that is the Dharma. He thought that something hidden needs to be discovered. For Nansen, his everyday life was Zen. What else is there to awaken to? When our mind is alive and vivid, alighting nowhere, that bright clear mind is what acts and functions. But we become caught by our ideas about this. The actuality of being one with heaven and earth cannot be divided into subjective and objective. When the eyes that see the world and the world that is seen are completely one and the same, we know for the first time the true essence of life.

Eternal time is expressed in the quiet serenity of the water that's so deep the bottom can't be seen. This is true stillness. Beyond any sound our body is pierced through by the cold winter air with which it has become one. How many have realized this true experience? Anyone can memorize the Buddha's or the Ancestors' words and repeat them, but can we manifest that state of mind? Forgetting time, forgetting your body, sit until you merge with the heavens and earth. Do zazen to this point and taste the flavor of this living actuality.

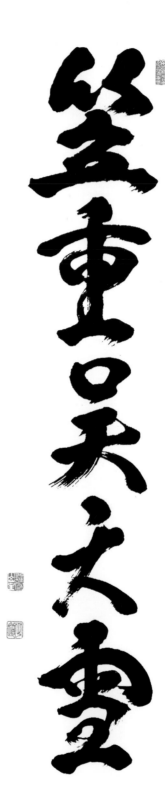

笠重呉天雪

Kasa wa omoshi goten no yuki
My bamboo hat is weighed down with Wu mountain snow

This line, from Hakuin's *Kaian Kokugo*, is a couplet with "My shoes are scented with flowers from fields in Ch'u."

In winter, the bamboo hats worn in the country of Wu become heavy with the fallen snow. In spring, the straw sandals worn in the country of Ch'u carry the scent of myriad flowers. For monks and people of training, there are good times and bad times along the Path. It was Daitō Kokushi who taught that people of training should always go in one straight line without stopping. We are born into this world to realize our True Nature. There is nothing but this in which to take refuge.

The Japanese Emperor Hanazono was training with Daitō Kokushi when he clarified the One Great Matter. Daitō Kokushi confirmed Hanazono's awakening and shared his great joy. Hanazono had not lightly attempted a year or two of practice but had done sanzen every day, never missing a chance. Finally he encountered his True Nature, seeing with the eyes and ears of the Ancestors.

Can you express that place with not a speck of duality? Everyone initially responds, "How can I express something that isn't there?" But one who has truly died and been reborn can easily and abundantly express that. When we actually return to our Source, we resolve the matter of life and death on the spot. There's no need to wait until our physical death to know this. We weren't born to live a life of confusion and melancholy. Every day we have to live with responsibility and serve people in society. This is the value of our being born, and in this we can find our true joy.

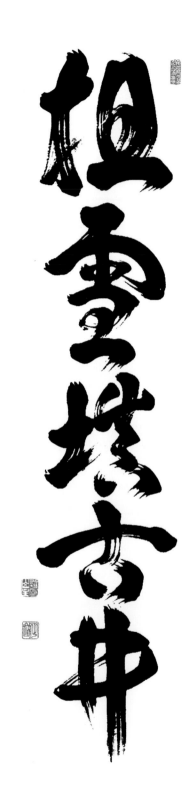

担雪塡古井

坦雪塡古井

Yuki o ninatte kosei o uzumu
They haul snow to fill the old well

These words express a world of making wasted efforts, of doing work with no possibility of fruition, of liberating all sentient beings.

In the Flower Garland Sutra, the monk Zenzai decides to visit fifty-three wise Zen masters, beginning with Tokuun. He has heard that Tokuun never leaves the peak of Myobucho, which represents his state of mind of enlightenment. Within Tokuun's mind, there is no speck of self or other, so how could he meet someone else? While Zenzai doesn't meet Tokuun on Myobucho, he does meet him on an entirely different mountain. For the sake of Zenzai, Tokuun rolls all the past, present, and future into one moment, the moment where all the Buddhas have their truth. For the sake of liberating all beings, Tokuun comes down from the mountain of form called Myobucho, but every place he goes is still that state of mind of Myobucho. Thus, in the midst of this awakened Mind, he liberates others.

No matter how much snow we put into a well, it won't fill up. We all know that. To leave our seamless world of oneness, going into the world of discriminating thought in order to liberate confused and deluded people, would seem as useless as putting snow down a well. Nevertheless, it must be done. "Sentient beings are numberless, I vow to liberate them." This is our vow.

There can be no Dharma essence without satori, but once we realize satori, we have to throw it away and, like a simple fool, dive into society. We must be exactly like Tokuun, remaining firmly in that place where no speck can settle, yet entering into society and manifesting this Mind. Otherwise, the Buddhadharma will be allowed to die and there will be no liberation of people in the world.

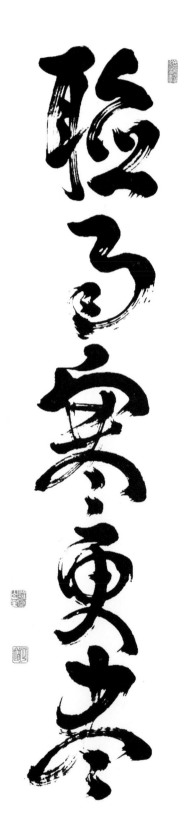

聴雨寒更尽

Ame kiite kan sara ni tsuku

Listening to the rain, I passed the cold night hours

This line is a couplet with "When I opened the doors, there were many fallen leaves." After a night of deep solitude, listening to the rain falling on the roof, when daybreak comes it's evident that what had sounded like rain was actually falling leaves.

A monk asked Master Taizui, "When the conflagration at the end of the eon comes and the universe is totally destroyed, is this One destroyed or not?"

Master Taizui answered matter-of-factly, "Of course it will be destroyed!"

The monk had been so certain that Buddha Nature is without birth and death. He thought that even if the physical world ended, the mind of enlightenment would be unaffected. He thought that those who have awakened are somehow separate. He was astonished at Taizui's answer and further inquired, "That which isn't influenced by anything, that which is the True Master, will it too disintegrate along with the world?"

Again, Taizui spoke directly, "Along with the world, it will be destroyed."

By seeking an absolute, the monk created two worlds. Taizui, speaking from actual experience of the One, responded that the monk's double-faced view would be destroyed along with the world. Without having known this experience directly, the monk could only conceptualize it. He was like someone who mistakes falling leaves for rain.

There's nothing sillier than searching for a world that we think will be like this or for something to be gained that we think will be like that. If we throw ourselves completely into each thing we do as we do it, our mind won't be buffeted. Even if there's an upheaval that roils the heavens and the earth, it's only a reflection in a mirror.

This does not mean we shouldn't have feelings; the sound of the rain brings a quiet, settled feeling that can be deeply enjoyed. Is our mind moved around by the situation, or can we truly just enjoy it?

寒松一色千年别

寒松一色千年別

This line appears in the *Record of Rinzai* as a couplet with "An old peasant plucks a flower—spring in myriad lands."

In the past, people marked the boundaries between properties by planting trees. Those trees would form a path through the mountains, and what a sturdy and fine sight they afforded. These boundary trees were never used for lumber, and so they were never cut down. They conveyed a feeling of endurance and stability, even when seen from afar.

In the same way people who reach an advanced age and know the struggles of life say, "One should not get too concerned and bothered about things but should learn to trust." When we are still in the springtime of our youth we can't know this mountain-tree state of mind. But if we don't spend our time running after what we want and instead quietly purify our being, we live long lives without thinking about it.

In Japan old people of the Path are considered to have four special merits: brightness, power, beauty, and joy. Those who have faced the greatest perils and suffered the deepest pains are the ones with the face of a living Buddha. When we see their faces, our worries and concerns vanish. We don't have to ask them anything; we become peaceful from just being around them. We let go of desires and are thankful for all the grace in the world and offer our Buddha Nature to all beings.

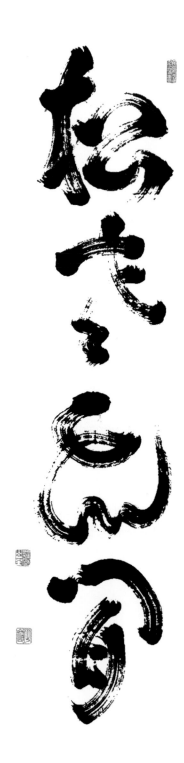

松老雲閑

Shō rō un kan
An aged pine, a floating cloud

These words are from the preface added to the *Record of Rinzai* by Ba Bo. They describe the abundant mind of someone not caught on anything, not seeking anything. To possess this kind of mind is to be like a fool. Thus Ba Bo praised Rinzai.

Rinzai's first karmic connection involved a pine. Shortly after he arrived at the temple of Ōbaku, Rinzai was alone deep in the mountains, planting pine trees. Ōbaku appeared and said to him, "You don't need to plant more trees, there are pine trees all over the place!" Ōbaku was testing Rinzai's inner depth.

Rinzai answered, "One reason is for the grounds of this temple to be even more removed from society in order to raise good people of training; another reason is to serve as an example to those who come after me." Rinzai wasn't talking about immortalizing himself but about expressing for future generations that mind free from ego or idle thoughts. Doing what we have to do, without leaving any ideas about it behind, is an important part of being well ripened.

Rinzai is often described as teaching with a great, huge energy, yet in his later years he was known to be silent, making no waves and living quietly and simply. This is the mind when efforts on behalf of society have been put away, entrusting to the next generation that which must be done. The state of mind of "An aged pine, a floating cloud" is to fulfill life completely to the end and then to go beyond that and let go of everything.

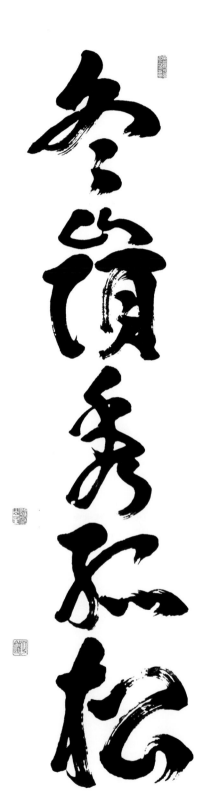

冬嶺秀孤松

Tōrei shu ko no matsu
On a winter peak, a lone pine stands tall

On a lonely and rustic mountain, in deepest winter, a mighty pine towers.

That which is immovable can come only from one's deepest realization and awakening. Year by year, the pine stands, during rainstorms and snowstorms, through winter's severe chill and summer's intense heat, not being moved by the challenges of nature. This life energy has to be experienced directly. This is truly the state of mind of the Buddhadharma. In each moment and in each place, not following along with circumstances, we can know that Truth. To awaken to this state of mind is the ultimate point of the Buddhadharma.

好雪片片不落別處

好雪片片不落別處

Kōsetsu hen-pen bessho ni ochizu
Such wonderful snow! Each flake falls in its place

These famous words are from Layman Pang. Although not ordained, Pang was very advanced at raising the Buddhadharma. His wife and two children also understood Zen deeply and lived an enviable family life of advanced Dharma exchanges. But Pang was seldom at the house. Instead, he trained for many years with Master Yakusan Igen.

When Pang left that way of training, Master Yakusan sent ten monks to see him off. As they said their goodbyes, snow came dancing from the sky. Pang said, "Such wonderful snow! Each flake falls in its place." This was his departing offering—a great feast that will fill you eternally with the truth of Buddhism exactly as it is, right here, right now. One who has manifested the root source of Mu will know what an excellent offering this was and will respond with gratitude. But one of the monks asked Pang, "So where do they fall?" Pang responded by slapping the monk across the face as if to say, "Where else is it going to fall?" With that Pang left. He had offered a great feast, and no one had been able to partake of it.

Who really sees those snowflakes that fall one after the next? What is the snow's truth as it covers the mountains, the houses, the forests in one layer of white? If we don't experience the root source of Mu directly, we'll only know the surface layer by way of mental explanations. I hope everyone will feast on this phrase and use it to deepen their practice.

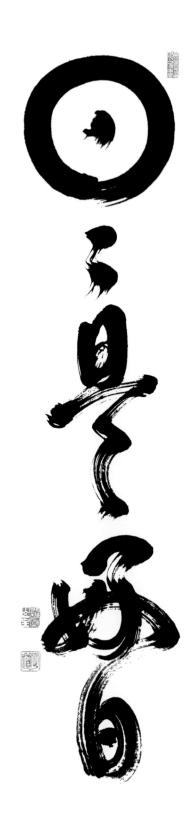

日々是好日

Nichi-nichi kore kōjitsu
Every day is a good day

These words, spoken by Unmon Bunne, appear in the sixth case of the *Blue Cliff Record*. Unmon was famous for his ability to cut the ground completely away, thus enabling a student to awaken. Working with him was said to be like venturing into a deep woods and suddenly seeing a red flag flapping in the distance signaling "over here!" If you superficially look at the words "every day is a good day" you will miss their point and never see that red flag.

When Unmon spoke to the assembly on the fifteenth day of the month, he said that he would say nothing about the days of the month that had already passed, nor would he mention the days that were to come. Instead he asked, "From this very moment with what state of mind will you live?"

To be full and taut, in this very moment, is the truth of the Buddha. When Master Unmon asked his question, not a single person could answer him. He answered himself, saying, "Every day is a good day." Cutting off the past, cutting off the future, letting go of any idea of a present, we experience our original clear Mind.

These words, "Every day is a good day," pierce through the past, pierce through the future, and pierce through the whole world in all ten directions, caught on nothing. This state of mind cuts away everything.

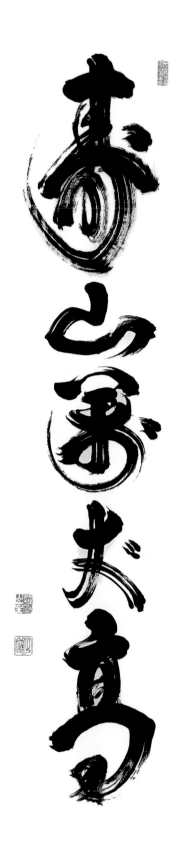

壽山萬丈高

Jusan banjō takashi

A mountain of happiness ten thousand leagues high

Those who live a long life are often respected, looked up to as one would look up at a soaring mountain. We all would like to live a long and fulfilling life, but we have to look carefully at the nature of that life. When we hold each day precious, we know how to keep our life in balance. Those who live with a feeling of abundance do not push and force themselves, nor do they push and force others. They see each thing thoroughly and clearly and move in a way that brings harmony and peace to everyone around them. When we live like this, without our even knowing it, little by little, our life's length increases.

The Buddha exemplified this way of living. Although the average lifespan in his day was thirty or forty years, he is said to have lived to eighty. As he walked he would carry a staff that made noise so that any insects along the path would know he was coming and could avoid being stepped on. When he drank water he always filtered it with a piece of cloth so he would not carelessly drink down a small insect. Even the larger animals were protected by and would protect the Buddha. In this way he lived each day giving great care to all living beings.

The Buddha did not just teach a doctrine; he actualized what he taught in the way he lived, keeping his sight on multitudes of lives. This is clearly the way of "A mountain of happiness ten thousand leagues high."

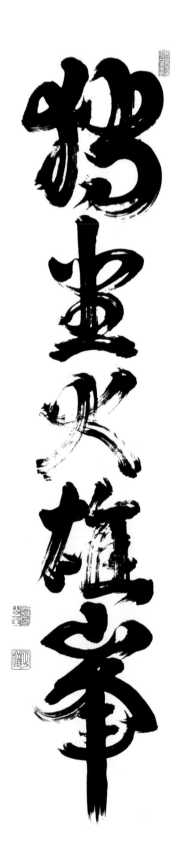

獨坐大雄峯

Dokuza daiyūhō
Sitting alone on Great Hero Peak

This phrase was given to us by Master Hyakujō Ekai. In his later years, when he was ripened, a monk asked him, "What is the most fortunate thing in this whole world?" People often think there is some mysterious power that goes beyond scientific understanding. Yet if our perception of God or Buddha is dependent on our beliefs, culture, education, or experience, what is it that is the same for each and every person? Religions originate from deep individual experiences. We can't become truly clear and secure from something given to us by someone else. If the monk had been answered with "Buddha" or "Dharma," he would not have been satisfied.

Hyakujō answered, "Sitting alone on Great Hero Peak." This was beyond the monk's expectation of an answer. Great Hero Peak was the mountain where his teacher lived, a place with so many peaks and valleys that it was impossible to know them all. In Hyakujō's great state of mind, there are no desires to cut off and no enlightenment to seek, no hells to be afraid of and no heavens to make requests to, no deluded people to look down on and no Buddhas to look up to. The joy and pain of the world are all right under Hyakujō's sitting cushion. This is a most fortunate place. Not depending on gods and Buddhas, here and now we find eternal time and space. Without knowing the deep actuality of this life's energy, what is there?

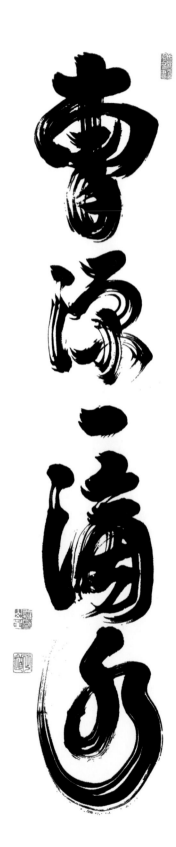

曹源一滴水

曹源一滴水

Sōgen ittekisui
Sōgen's one drop of water

These words describe the flow of the essence of the Dharma from the mountain temple of the Sixth Ancestor. This one drop is the Sixth Ancestor's truth, the ultimate point of Zen where words and phrases cannot reach.

A master at the temple Sogen-ji named Gisan Zenrai made excellent use of these words. One day a monk named Giboku was preparing the master's bath. Because the water was a little too hot, he brought buckets of cooler water from the well. When the bathwater was just right, a few drops of water remained in the bucket, and he poured them out on the ground.

Gisan Zenrai saw that and said, "What did you just do?"

"I threw away some old water," Giboku answered simply.

"If you do training with a mind like that, no matter how much training you do or how long you train, you will not awaken. If you dump that water out there, how can it be used? If you take it outside to the vegetable garden, the plants will be given life, and the water too will be given life." Giboku realized how little he actually understood. Something as simple as a single drop of water had taught him that he had to start his training over. This he did, later becoming a great Zen master and taking the name Tekisui.

Although money and possessions can be used up, when a teaching is used it becomes more and more radiant. The Sixth Ancestor's teaching was given great respect by Master Gisan and further life by Master Tekisui. Using water as a metaphor, they taught about Buddha Nature, the awakening of the true eye that allows us to see all the way through to the essence of each thing, no matter what it might be.

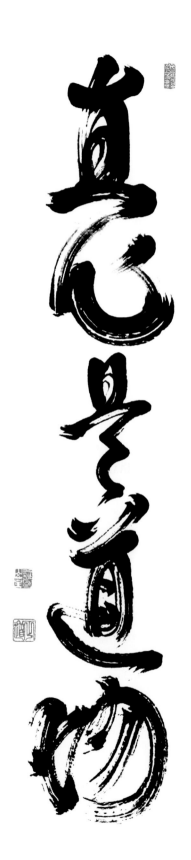

真心是道場

直心是道場

Jikishin kore dōjō
Straightforward mind is the place of practice

These are the words of the great layman Vimalakirti.

One day as Koun Doji was about to leave the city, he met Vimalakirti, who was just returning. He asked Vimalakirti where he had been, and Vimalakirti replied that he was coming from the dōjō, the place of practice. Since there was no dōjō except for the Buddha's, Koun found this mysterious and asked Vimalakirti to explain.

Vimalakirti answered, "If you think that a dōjō is a place or a building, that is a problem! If you think of it as some building that you can enter and leave, then the essence of your mind will be always changing. The Buddha said, 'If you continually actualize this Dharma wherever you are, then the Dharma Body will be ever realized, and that is without death.' When the Buddha was saying this, was he talking about a dōjō of form and location?"

There are many sacred sites, but where is the living Buddha? When our mind is liberated, everywhere we go is a place of practice. When we understand the Dharma in our deepest mind, then every day we are with the Buddha, no matter where we are.

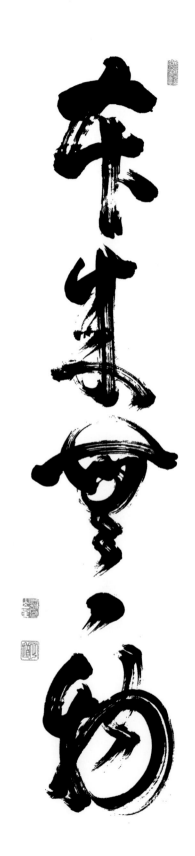

本来無一物

Honrai mu ichimotsu

Originally not a single thing exists

These are the words of the Sixth Ancestor, Rokuso Enō, written when he was training under Master Goso Gunin. Gunin's chosen successor, Jinshu Joza, had offered this poem:

> Our body is a bodhi tree,
> Our mind a mirror bright.
> Carefully wipe them all the time
> And let no dust alight.

When Enō heard these lines he wrote another poem in response:

> There is no bodhi tree,
> Nor stand of a mirror bright.
> Originally not a single thing exists,
> Where can dust alight?

Our mind may be likened to a mirror, but any idea that there is such a thing as a mirror is already a mistake. From the origin there is not a single thing. Our original state of mind has not a single mind moment. To become enlightened to that is satori. With this body we manifest Mind, but that which is manifested is without form or substance. This is where we all are equal. If we don't have this fresh awareness, letting go of each thought as it arises, we lose track of the Truth. That is what the Sixth Ancestor meant when he said, "Originally not a single thing exists."

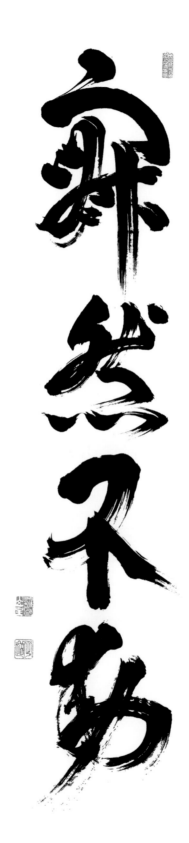

泰然不動

寂然不動

Jakunen fudō
Serene, unmovable

The kendō sword master Takuan defined "the unmoved mind" as that mind of no mind-moment, no form. If you think this means that no matter what comes along your mind doesn't move, you are mistaken. We cannot turn our backs on other people, looking out only for our own well-being and state of mind. That kind of mind would be especially use-less in the case of kendō. Someone who tried to preserve a special state of mind would be cut through by the opponent's sword immediately. Unmoved mind is the mind that is not stopped by anything, not caught on anything.

As soon as we get caught on something, we stumble, and it's here that mind's delusion is born. When we judge, that which we judge pushes us around. When we are moved around, the notions of profit and loss are born. To think that we should try and stop the mind is to go against what is natural. When our mind is completely objective and clear, that is the unmoved mind.

Because mind has no fixed substance, it's pure and clear, but there's no need to get caught on ideas about that. When we experience this state of mind we naturally realize that we are pure and serene already. This is the state of mind of "Serene, unmovable."

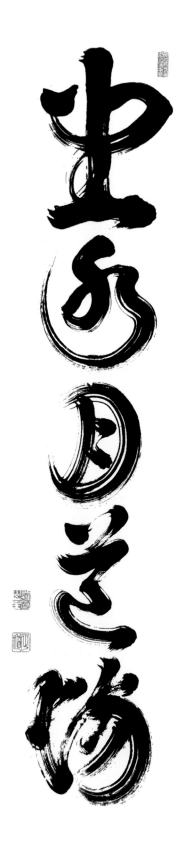

坐水月道場

Suigetsu no dōjō ni za shite
Sitting in the Moon Water dōjō

No matter how much we analyze the contents of water, we will not be able to locate the moon there. Yet as soon as water is clear, we can see the moon reflected in it. This is true whether the water is a small puddle or a great ocean. It can be muddy water or water in a bowl, water in a bucket or in a well; it can be the dew on a wildflower or the piss of a carp in the pond. If it's clear and still, without fail the moon will find its way there. No matter how we search the human body, even if we do an autopsy, we won't be able to find a mirror anywhere, but when our mind settles and becomes clear, the mirror-like functioning spontaneously comes forth.

This is our essence. No matter how many evil acts a person commits, no matter how ignorant or simple someone seems, when it comes to the true body of Mind, those measurements don't hold. If our mind is clear, if we can enter samadhi, the moon will shine there without fail.

To sit in the Moon Water dōjō is to realize this place where the moon and the heavens and the earth are all me, to know that we have never, even once, been born or died. This is not a state of mind we have to produce; everyone is endowed with it. Being overwhelmed by extraneous thoughts and attachments, we merely lose track of our Buddha Nature.

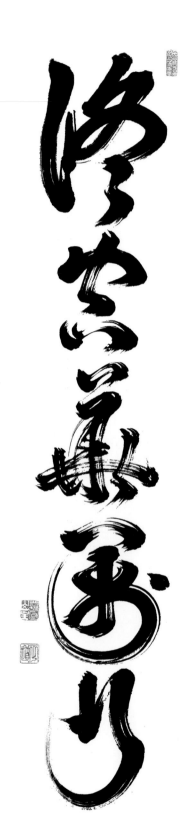

修空華萬行

Kuge mangyō o shū su

Tracing flowers in the sky

This line is a couplet with "Sitting in the Moon Water dōjō." With the condensation of the chilled air on a winter morning, small, shiny apparitions sometimes appear in the sky. There is in fact nothing there, but there is shining.

That place where there is nothing in the heavens and the earth obstructing us, and nothing below us to support us, is the state of mind of knowing Buddha Nature just as it is. The millions of years of this planet Earth and even the expanse of the universe are still only like a tiny bubble in the middle of the great ocean. That huge expansiveness is the state of mind to which we awaken.

Like lightning, each person shines brightly and then disappears. We are the scenery of a moment. Yet even if this world should vanish forever, in that infinite eternal Buddha Nature there is not the slightest disturbance. Our deep vow to liberate the numberless sentient beings and the compassion that comes from our deep samadhi will not be destroyed even in the greatest crisis. To make that vow and be determined to keep it is the Path of the Buddha.

"Tracing flowers in the sky" is an expression of our deep faith in that immovable state of mind. No matter what we encounter it's always new, a manifestation of our great deep vow and our truth. This is the actuality of the empty flowers in the air. We must directly experience those flowers and the truth of that infinitely changing, unmoved Mind. This is the ultimate point of Buddhism.

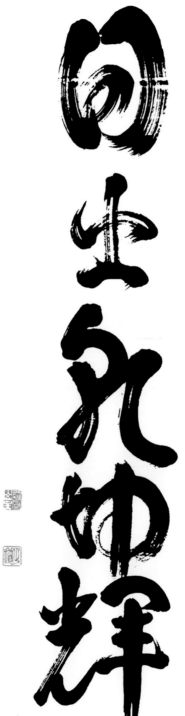

日出乾坤輝

Hi idete, kenkon kagayaku
The sun appears lighting up heaven and earth

This line, spoken by Daitō Kokushi, is from the first section of Hakuin's *Kaian Kokugo*.

According to tradition, the Buddha was the first human to realize the eternal. This was the source of human liberation, the sun rising after a long night's darkness. When the sun shines, the whole world is bright and clear: the mountains and the rivers, the flowers and the birds, the houses and the people in turn all shine with freshness. When the clouds depart, the mountains' form can be clearly seen. With the great light of the wisdom of the Buddha, we are able to know that all beings are essentially Buddhas. When the clouds of ego are swept away, our dark world instantly becomes one of light. The mountains, the rivers, the woods, the flowers, the birds, the animals, the insects, the people are all wrapped in the Buddha's great light.

We express gratitude to this great awakening of the Buddha, bowing to the sun rising in the sky. That awakening of eternal wisdom is what guides our Path and that of all humankind.

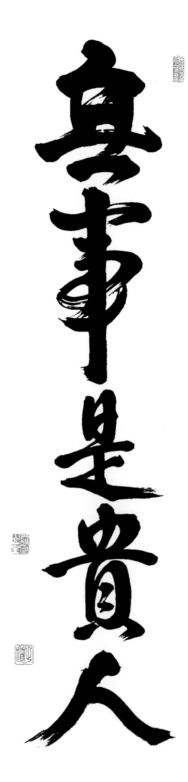

真事是貴人

無事是貴人

Buji kore kinin

The person of value is the one who has nothing to do

These words are from the *Record of Rinzai*. The Buddha taught a correct way of living, of looking at the world, and of seeing clearly. To free others from confusion, the Buddha taught the awakened Mind's way of seeing.

The best way of living is to function from that place where from the beginning there is not a single thing. When no speck of doubt or dualism remains, we see clearly. We are no longer influenced by notions of life and death, good and bad, love and hate, gain and loss. Amid all of these, we will not be pushed around by them.

If we live with this wisdom, we come and go freely. When we allow ourselves to be caught, we lose our freedom. We have to throw away our small way of thinking and live in a place where we hold on to nothing whatsoever. It's here that we discover the Buddha, and there is nothing sturdier than the strength that comes from this discovery. There is no greater truth.

In a dualistic world we will fumble and fall. When we see with the eyes of the Buddha, we know the joy of the Dharma in daily life. We become one with the heavens and earth, and there is no longer any division between inside and outside. There is no longer a need for doubt and no place for it to arise. The person of value is the one who knows that state of mind of holding on to nothing at all. That is the person who has nothing to do.

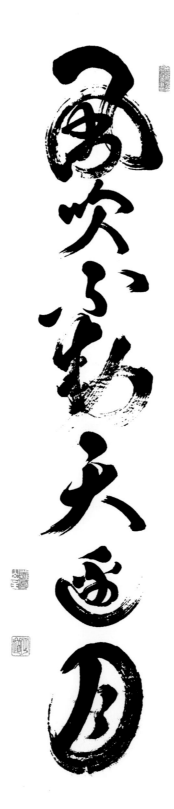

風吹不動天邊月

風吹不動天遍月

Kaze fukedomo dōzezu tenpen no tsuki
Though the wind may blow, the moon in the sky does not move

This phrase from the *Comprehensive Record of the Lamp* describes the state of mind of not being moved off-center by anything. People are often moved around by a fear of being insulted, either behind their backs or to their faces. They are even more often moved around by happiness and sadness. People waste their lives trying to avoid pain and to have as much pleasure as possible, never having a true center but being pushed and pulled every which way.

Zen is about letting go of all ideas of ourselves as men or women, as young or old, as scholars or nonscholars, as rich or poor, as evil or good. Rather than becoming conceited about ourselves or judging ourselves, we can see whatever arises as nothing more than a reflection in a mirror. It is when we are caught on our own appearance and form that we get moved around. While being within the many forms of external reality, when we remain unattached to any of them we are in serene samadhi. This is "Though the wind may blow, the moon in the sky does not move." This is the very wisdom the Buddha manifested.

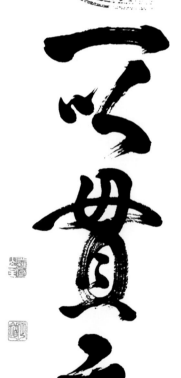

吾道一以貫之

吾道以一貫之

Waga michi ichi o motte kore o tsuranuku
There is One Thing that runs through my teaching

This line is from the teachings of Confucius known as the *Analects*.

Master Confucius said to his disciples, "There is One Thing that runs through my teaching." His senior disciple, Soji, responded, "Yes, that is so," and received the teaching.

After the master left the room, all the other disciples asked Soji, "The master said that there is only one virtue, but what is it?" Soji answered, "This one Path is that of compassion. Only this."

Confucius was saying that all of the virtues he had taught until that time were actually just one teaching. The virtue with which we are endowed from birth is not the same thing as the wisdom that arises from what we think about after birth. This bright attribute is our Original Nature, beyond all divisions into countries, cultures, or languages. It can't be bent to accommodate just one person's wishes. It is that which applies equally to everyone, that which every person will understand and agree upon, that in which we can take refuge because it connects all human beings.

When we understand the nature of being human, we love all humankind beyond any division into good and bad. We realize the purity that is within each person and can rest in the state of mind of being one with all people. That is what Confucius taught.

法尔有序

徳必有隣

Toku, kanarazu tonari ari

Virtue is never without company

In the *Analects*, Confucius said, "Virtue is never without company. It will always have neighbors."

Peace of mind and external peace are not separate. Before we try to construct an external world of peace, we have to extinguish the seeds of conflict in our own heart.

Our deep Mind sees everyone's happiness, and where this deep Mind is expressed, people of virtue gather. When our Bodhisattva Vow is firm, our essence will naturally allow others to awaken to the same vow. This is the meaning of "Virtue is never without company."

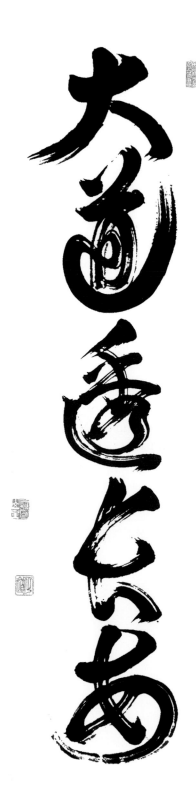

大道通乾坤

大道透長安

Daidō Chōan ni tōru
The Great Way leads to the capital

One day a monk came to Jōshū and asked, "What is the Way?" Jōshū answered, "The path? It's just outside the fence." The monk tried again. "I am not asking about such a small path. I am asking about the Great Way." Jōshū said, "The Great Way leads to the capital."

In Buddhism the mind is the Way. This mind is not the thoughts of our ego, but the depth beyond all ego, where we are clear and pure and free of stains. This true base is immense beyond measure and has infinite functioning as well. That which is functioning surges forth full and taut, completely pure, beyond name or form. It can't be said to exist, and it can't be said not to exist. It has no thoughts and only speaks what is necessary with no idea of having spoken; free of ideas, it matches perfectly with each moment's encounter. When we realize this way of being, we are advanced followers of the Way. When our clear mind moments become one with the world, our mind and the world are one; no matter what we see, it is Truth, and it is Buddha. We know "The Great Way leads to the capital."

The small road in the countryside, the path of the loggers in the woods, the wide highway, and the all-embracing Great Way all lead the capital. This is not a path of form but the path of our mind, the pure, unstained Way that joins all the myriad things. If we know this Path of Mind, everything is the Truth of the Buddha.

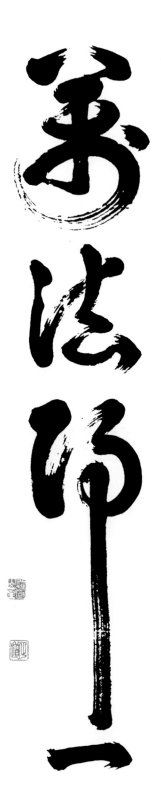

萬法帰一

Banpō itsu ni ki su
The ten thousand things return to One

Master Jōshū was asked by a monk, "All of the myriad existences return to the absolute One, but to where does that One return?" If we do even a little zazen we know the place where all things return to the One, but we can't stop there, thinking that emptiness or an absolute is all there is. If it's not clear where the One returns to, then our Zen is poison, separated from the actual world, a nihilistic trap to which all of humans' abundant, creative capability is lost.

Jōshū responded, "When I was in Seishu I made a hemp vest. It weighed seven hundred grams." Where in Jōshū's response is there an answer to the monk's question? He seems like an absent-minded grandfather replying to a grandchild, but this is in fact a splendid response to the question at hand.

If we get caught on the words of others, we'll be dragged down into a game of explanations. In Zen, experiencing the great death and being reborn is what is most important, and that's what is being expressed here. If Jōshū had said, "That's the One!" he would have been completely tangled up in the monk's question. Instead he expressed that refreshing clarity where all dualism and explanation end. This is the mind of Zen.

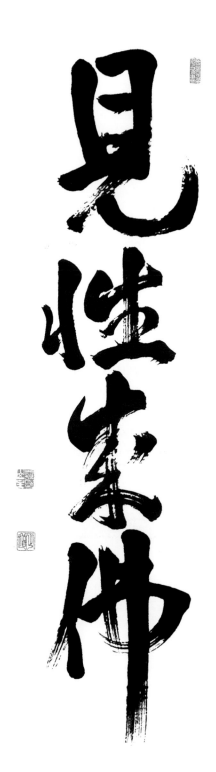

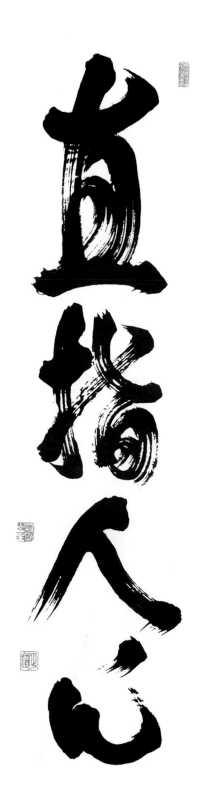

見性成佛
直指人心

直指人心
見性成佛

Jikishi ninshin
Kenshō jōbutsu

Point directly to Mind
See your true Self and realize Buddha Nature

The Buddha's incomparable teaching, the Path of awakening, cannot be taken lightly. It's attained through diligence in practice and by enduring that which is difficult to endure. You have to be willing to throw your self away completely, beyond what you imagine possible. If you think you already know something, you won't be able to realize this Mind.

Niso Eka had read and studied all of the philosophers and still wasn't satisfied. So he went to see Bodhidharma and said, "My mind can find no relief. Please liberate me." It took a depth of experience to make this request, and Eka was willing to put his life on the line.

"Bring me that mind, and I will pacify it for you." Bodhidharma wasn't playing with words. He could see that Eka had come to the end of what could be spoken and conceptualized and gave the last slash.

Eka replied, "I can't do that. It can't be found."

Bodhidharma said, "See? I have pacified it." The mind isn't there; it is *not there*! If you truly understand this, you will know true peace and the end of all doubt. That place where there is not a thing to hold on to, nothing to seek, nothing to clutch: here is true peace.

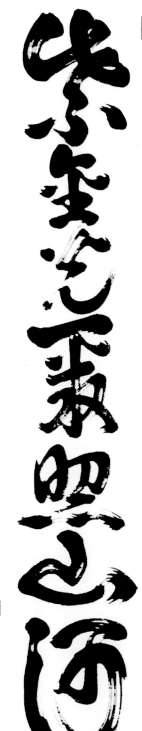

紫气东来照山河

紫金光聚照山河

Shikin kōjū senga o terasu
Purple-gold light illumines the mountains and rivers

This verse is from the fourth section of Hakuin's *Kaian Kokugo.*

The purple-gold light is the radiance that shines forth from the body of the Buddha, illuminating the mountains and rivers, shining on everything in this world. The awakening of the Buddha awakens all humans, casting a glow on all things.

The sutras tell of a huge dark field filled with countless plants that, because of the lack of light, can't be plowed or tended. The plants are despondent and melancholy. An awakened being arrives carrying a glowing torch that illuminates the entire field. The plants that have been low and isolated in the darkness stand tall in the light, each astonished to see that it's in the midst of many others. This field is life, and the darkness is not knowing the light of real wisdom. The light-bearing stranger is the Buddha.

No matter how many tens of thousands of people live in the same country, if they can't see one another, each one lives alone. The light of true wisdom helps us to see each other and live harmoniously. The light of the Buddha brings a profound joy. If just one person awakens to this, then everything in existence, all of the trees and grasses and all beings, becomes Buddha. In this way, just one Buddha's awakening becomes the true awakening of all beings. One being's awakening illuminates the whole world and brings light to all people.

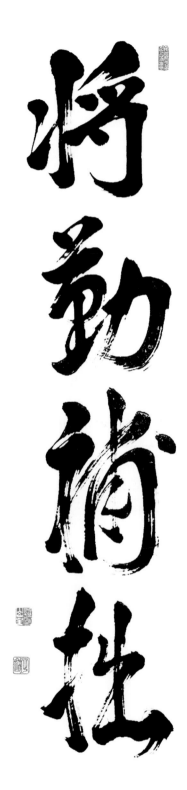

将勤補拙

Gon wo motte setsu wo oginau
To make up with diligence for his inability

This line is from the thirty-second case of the *Blue Cliff Record*.

No one is perfect; it's human to behave unskillfully. Once we know where our faults lie, it's up to us to look at them and work on them.

When Tei Joza was training with Rinzai, he asked him, "What is the body of the Buddha-dharma?" Rather than answering, Rinzai grabbed Tei Joza by the lapels and hit him. Tei Joza fell over and almost passed out. As long as we rely on explanations and mental habits, we cannot know the true origin of the universe. These blows were one of the ways in which Rinzai could teach Tei Joza through a living process beyond explanation.

When Tei Joza was barely able to sit up, one of his seniors said, "Prostrate! The koan is over." Tei Joza immediately prostrated, and for the first time he clearly saw beyond rational understanding and judgment. He had trained diligently, using his practice to work on the aspects of himself that he knew were unripe and undeveloped. In the dōjō he did things secretly that no one else wanted to do, such as cleaning the toilet and polishing the floor. Because he had purified his mind in this way, Tei Joza could prostrate naturally, without even thinking, and through this a new life was born.

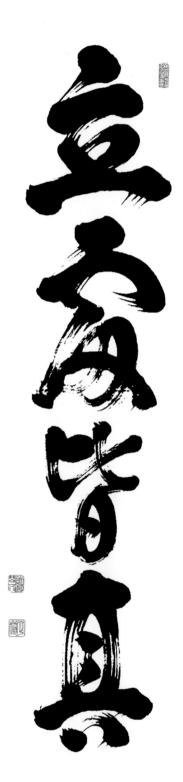

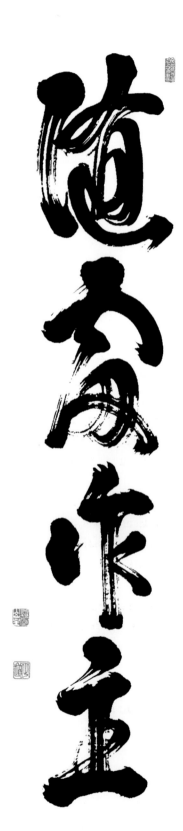

随處作主
立處皆眞

Zuisho ni shu to nareba
Rissho mina shin nari

Be master wherever you go
Then wherever you are, things are as they truly are

This is the most famous verse of the *Record of Rinzai*. If we stay in our true center, then no matter where we go, anything we do is Truth. But where is this center?

Rinzai said to his students, "You of the Path, if I was to say what is most important, it is confidence." True confidence arises when the mind that believes and the mind that is believed in are one. The Buddha said to Ananda, "Be a refuge unto yourself, take the Dharma as your refuge. Be your own guiding light, make the Dharma that guiding light." This is what's most important. The Truth that pierces through the past, present, and future doesn't change. Unless we awaken to this Truth of not holding on to anything, of no self and no other, we'll be confident only when things are going the way we want them to go. The Path of Zen is not limited in that way.

We have to make use of our surroundings rather than being used by them. The limited confidence of the ego depends on an external position, and when that position is gone, its confidence is gone as well. Instead of looking at others, we should look at ourselves. Instead of being used by others, we can be the master. Our states of mind are like any vehicle: in order to function, they require someone able to use them.

When we completely become whatever comes along, there's nothing left that can move us around. Yet with one superfluous idea the devil of delusion appears and even a Bodhi-sattva becomes a devil's vehicle. This is what happens if we look outside ourselves for the Truth.

When we don't allow our mind to become divided, we can know this place of confident functioning and what it means to be that person of the Path who relies on nothing. We are master wherever we go, and wherever we are things are as they truly are.

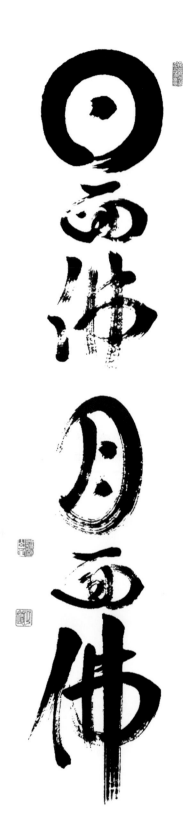

日面佛月面佛

Nichimen butsu gachimen butsu
Sun-faced Buddha, Moon-faced Buddha

The verse is from Master Baso Dōitsu. About one month before his death, Baso Dōitsu was walking in the mountains and came to a fairly wide-open space. Pointing to it he said, "Bury my bones right here." The next day he was bedridden. The day before his death, the local official responsible for the temple came to visit him and asked, "How are you feeling?" Baso Dōitsu answered, "Sun-faced Buddha, Moon-faced Buddha."

Sun-faced Buddha and Moon-faced Buddha are two names in the Sutra of the Three Thousand Buddhas. The Sun-faced Buddha is eighteen hundred years old, and the Moon-faced Buddha is one day and one night old. Baso Dōitsu was answering that he was both a long-lived Buddha and a short-lived Buddha. When there are Buddhas who live eighteen hundred years and Buddhas who live only one day and one night, something like sickness is no problem!

We have to see clearly that at the moment we are born, when we give that great birth cry, we are holding on to nothing at all. There is only that great cry, as it is. This is true not only of the Buddha but of everyone. Likewise, the end will come for each and every one of us, whether we're enlightened or not, but those who do not awaken to this truth live a life of delusion, mistaking ego for the deepest value.

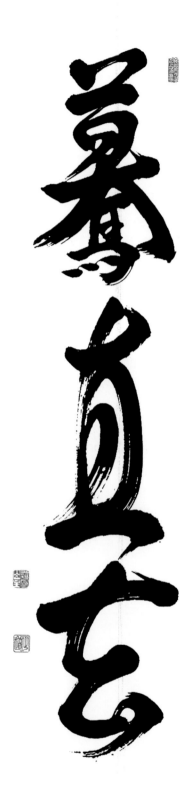

驀直去

Maku jikko
Go straight!

This line is from the thirty-first case of the *Mumonkan*.

Near Jōshū's temple was the sacred mountain of Godai, and many monks traveling to the temple wanted to visit the mountain first. At the crossroads sat a teashop run by an eccentric old woman. Whenever someone stopped and asked how to get to Mount Godai, whether they came from the east or from the west, she would say, "Go straight!" Having been told that, everyone would continue straight ahead. But as soon as a monk had taken a few steps, she would always say, "He appears to be a fine monk, but just look at him going off in that direction!"

This happened to so many monks that they finally complained to Jōshū. The next morning he went to the teashop and asked the old woman the way to Mount Godai. Her response to Jōshū was exactly the same as her response to everyone else: "Go straight!" But Jōshū went back and said to one and all, "I saw through that old woman today!" But what did he see? Did he see her as enlightened or as ignorant? Was she just bullying people? Or was she stuck in good and bad? This is the central question of the koan.

People know they should go straight, but they also want to rely on someone. They want an idea on which they can depend or an environment in which they might be safe. That's not straight. People are always saying that this or that is better, or that it's not like this or that. When there are no longer any choices to make, we can only go straight. If we don't see this, we risk missing the message the old woman gave to the monks and what Jōshū saw so clearly.

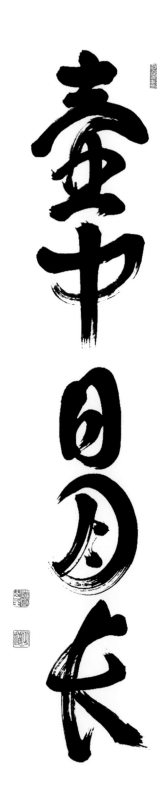

壺中日月長

壺中日月長

Kochū jitsugetsu nagashi

In the pot, sun and moon shine eternally

There was an old man in a small town who operated a pharmacy. In his store was a big jar of medicine, and that one medicine worked for any malady. No matter who came in or what their problem was, the jar's contents fixed it. Everyone in town trusted the man and his medicine implicitly. But no one knew where he lived. In the evening they would see him closing the shop, but no one ever saw where he went. Each night, the old man waited until no one was looking and then secreted himself in the jar that held the medicine.

Eventually, a town official who lived nearby noticed this. The next day, the official went to the old man's store and greeted him with great respect with gifts of sake and rich food. Immediately the old man understood that the official knew his secret. "You want to go into this big jar, don't you? Well, I will help you. Hold my kimono and close your eyes, and you can come with me."

The official did as he was told, and suddenly his body shrank. The old man then told him to open his eyes, and what he saw was a different world! How huge and spacious everything was! He saw an enormous house and a great garden filled with flowers and trees with ripened fruit. In the lake many fish were swimming, and the many rooms of the house were filled with treasures. He forgot about the passing of time. Though normally he was consumed by work and worry, here his troubles vanished.

He wondered how this could be. Because the old pharmacist could know his thoughts, he said without prompting, "I am from an enchanted land. Because I made a mistake, I was sent down to Earth. Now I have been forgiven and can return to the world of gods and heavenly beings. I saw your heart of goodwill, and I wanted to show you a little corner of this heavenly realm, but this isn't a place you can stay. Let's drink a cup of sake together and then say farewell." The official drank the sake and felt woozy. When his head cleared, he found himself back in his office. He knew that the world in the pot was beyond time and space, an absolute world within our mind.

The sun and moon shine within all of us. To realize the source of this true Big Mind and not be moved around by things is what the practice of zazen brings us. We can all realize this absolute power within our own life and mind.

海納百川翔

海濶百川朝

The sea is vast and the hundred rivers flow toward it

These words are from the fifth section of Hakuin's *Kaian Kokugo*.

In a vast ocean, no matter how much water is added, it never seems as if there's too much. Likewise, our mind is as huge as the Buddha Land. Einstein said that the greatest miracle in the universe is that we can understand. When we look at it this way, we realize we can hold the entire universe in our mind, in the same way that a drop of dew is held on a leaf. Our mind is so huge, so enormous, that it can drink down everything. All truths can be brought into awareness.

When we swallow each thing down, we don't miss the next one; we function totally, aware of every single thing. We have the potential to function and express ourselves in small, subtle ways. But when we make everything small by squeezing it into a narrow frame of ego, we can't see with this expansiveness.

In doing zazen, we realize this mind of "The sea is vast and the hundred rivers flow toward it." We drink down the waters of all the rivers and still don't think of it as a lot. It's this kind of mind we all need to have.

The essence of the Buddha's awakening is not about knowledge. It's not something you can understand by just asking and listening. When you've completely thrown away your small self, when every last speck of thought has been let go of, you'll be able to receive that which surges forth freely from within.

庭前柏樹子

庭前柏樹子

Teizen no hakujushi

The juniper tree in the front garden

A monk asked Jōshū, "What was Bodhidharma's intention in going to China?" Jōshū answered, "The juniper tree in the front garden."

When Bodhidharma sailed from India to China, it was a huge adventure. What was his intention in going so far? Rinzai said that if Bodhidharma had had the slightest bit of intention, he couldn't have saved even himself. If he had had the least bit of self-conscious awareness of wanting to save someone, that would have been an egoistic thought. But if there was no intention, why did he go so far? The monk was inquiring about Bodhidharma's mind as a way of looking at how his own mind should be.

The monk thought Jōshū's answer was referring to their surroundings, but Jōshū was in fact expressing his own truest state of mind. Does a tree intend to provide shade? Of course plants don't have intention in the way that humans do, but then why do they bring forth such beautiful flowers? Why are they so lovely in form? Is there intention in this universe or not?

In our everyday life, no matter how honorably we act, no matter how splendid what we do seems, if we act with self-conscious awareness our actions will become confused. If we have an idea of having done something, or of having made great efforts, we suffer from it. When Jōshū said, "The juniper tree in the front garden," he was not proclaiming a rehearsed idea but entrusting to the whole universe. The tree, in front of our eyes, has stood for a hundred or more years. Every day, whether in the rain or in the sun, in the heat of summer and in the cold of winter, it continues manifesting its energy, providing shade, creating the oxygen we need to breathe. The juniper tree in the front garden is one with the heavens and earth.

孔神の一人

乾坤只一人

Kenkon tada ichinin

In heaven and earth, there is only one person

When the Buddha was born he took three steps, raised one hand to the sky and pointed the other to the earth, and said, "In heaven and earth, there is only one person." He didn't mean, "I'm wonderful and there's something lacking with you." A newborn baby can't walk or speak, yet the Buddha expressed these words with his whole life. A baby gives its birth cry of *WAAAAAA* with every ounce of its strength. This is our expression of "In heaven and earth, there is only one person."

We always want to blame shortcomings on someone else. This is foolish. There is no such thing as a bad person. It's indulgent to form an idea of a bad person when we have this huge Mind that can accept and receive everything. We have the Truth within and don't need to rely on someone else.

All the Buddha's sutras are about becoming free and expressing compassion and wisdom. Awakening to a Mind that gives life to this compassion and wisdom is what is most important for all of us. That's the whole of his teaching. Everything in existence has Buddha Nature. All the trees, grasses, mountains, rivers, animals, and flowers are Buddhas. "In heaven and earth, there is only one person" is about seeing all beings as Buddhas. It's the expression of the Buddha's enlightenment that was made on behalf of all people.

We have to accept the responsibility of treating all beings with compassion and under-standing. We have to make these words our own.

平常心是道

Heijō shin kore dō
Everyday mind is the Way

These are the words of Master Baso Dōitsu. Those who have realized deep awakening know how to live each day. But how do we go about it? What's the best possible way to live so that our life has value for all beings?

Our Original Mind is like that of a newborn baby. When we live in that naturally clear Mind, just as it is, that's everyday mind; that's the Path. But when our mind is filled with ideas and prejudices, perceptions about economics, politics, and social issues, how can we see clearly? If we could all live from a place of ordinary, everyday mind, we would have no need for religion and education and laws. When we are not concerned with anything at all, this moment is always the best time and season. If we encounter a crisis or catastrophe, that's fine; when we die, that's okay too. Instead of seeing things as good or bad, we know that that's how it is. When we reach the end of our life, we can't keep on living just because we aren't yet ready to die. We must realize this deepest source, not to prevent physical death, but that we might live a life in which dying is only one of many things that come along.

古松流絵考

古松談般若

Koshō hannya o danzu

The old pine is speaking prajna wisdom

This line forms a couplet with, "The mysterious bird is singing the truth."

Normally we see our body and the rest of the world as separate; we live a life apart. When our world and our body meld, we experience the awakening of the Buddha, becoming a perfect whole. Our zazen isn't for playing around with our own thoughts. This world is filled with problems; our bodies are imperfect too. But putting everything aside and becoming one with this world, completely and totally, is what has to be done.

When we live in accordance with the great way of nature and open our wisdom eye, then everything in existence is teaching prajna wisdom, and the truth is expressed everywhere. The wind blowing through the pines is the Buddha's teaching. As the trees bend and moan, that sound is the very teaching of the Buddha. We don't think about receiving it, but with our whole being we become it.

We can't do zazen only to forget our body and let go of our thoughts. Realizing emptiness is not the goal. Having realized emptiness, we then have to become a truly dignified, high-quality person. Then, no matter what we encounter, it arises from our wisdom and polishes our wisdom, enabling the bright light of the Buddhadharma to shine brightly and illuminate everything. In becoming this world we discover our true worth.

遠山無限碧層層

Enzan kagiri naki heki sō-sō
Mountains endless into the distance, layer upon layer of blue

This line is from Setchō's poem for the twentieth case of the *Blue Cliff Record* regarding the meaning of Bodhidharma's coming from the West: "I never tire of the evening clouds before the dark descends—Mountains endless into the distance, layer upon layer of blue."

Stop the cluttered thinking and go outside and see! The evening clouds are just starting to wrap around the mountains. The sun is setting behind the western mountains, but the sky is still glowing red. The mountains follow one another in such a way that they seem to reach to the very edge of the universe. Our Original Mind is that huge. We have to look closely at this rich, immense scenery and receive it within.

This Mind is not about someone else but about our own wisdom and functioning. We have to let it become our flesh, blood, and bones and in every single day learn from whatever comes our way, drinking it all down again and again, until every last thing is melted into our body. And when we reach that point, there isn't any more good or bad; there's nothing to resent. It's all been washed away. Only when we let go of everything can we know this clarity. By not running away from either praise or insults, we further polish and fulfill our human character. This is what is most important.

As we look back, the mountains we have passed through form a continuous line behind us. As we look ahead, we see mountain after mountain with no end. We can know this infinite state of mind and live in this boundless world.

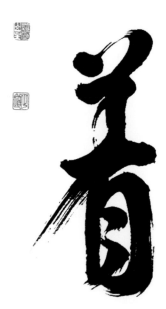

放下著

Hōgejaku
Throw it away!

Genyō asked Master Jōshū, "When I am holding on to nothing at all, not one single thing, and nothing is occurring, and there is not even anything to say, how about that?"

Jōshū answered, "Throw that away too!"

Genyō pursued his question. "I just told you that I'm holding on to nothing at all. What is there to throw away?" He had not yet clearly seen the true base of "nothing at all."

Jōshū replied, "Then carry it around. Lug it along with you."

To self-consciously try to construct a mind of purity is to get caught on an idea about purity. To try to be pure is not pure. During zazen, if we think about not thinking, we're filling our mind with thoughts about a mind that is free of thoughts. That's a mistaken notion that muddies our Original Pure Mind. We can't try to aim for purity or pursue invented ideas. To open our mind and accept everything without getting snagged on anything or following anything around is what is most important.

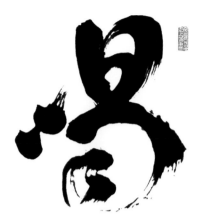

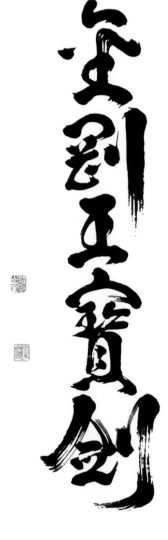

曾到五寶劍

喝　金剛王宝剣

Katsu! Kongō'ō hōken

Katsu! The jeweled sword of the Vajra King!

Master Rinzai is known for his great shout of "*KATSU!*" For those of us in the line of Rinzai, the great shout is a dynamic means for giving life to our vivid energy. That one word, *katsu*, deeply manifests our most human quality, that place where there's no room for any mental idea to be inserted.

It would be meaningless to attempt to summarize the 5,048 sutras of the Buddha and the whole of his life in a single expression. The shout of Rinzai isn't a summation of the teachings; it is the actual essence of the Buddha. The Buddhadharma can't be conveyed by explanation. Only by being in this very moment and experiencing the life energy that fills the entire universe can we express it. Our awareness as it is, just that, is the truth of the Buddhadharma.

Rinzai said, "Sometimes a shout is like the jeweled sword of the Vajra King; sometimes a shout is like the golden-haired lion crouching on the ground; sometimes a shout is like a weed-tipped fishing pole; sometimes a shout doesn't function as a shout. How do you understand this?"

This shout works to cut away all desires and incidental thoughts completely and totally. It kills Buddhas and kills Ancestors; it kills everything we've ever been thankful to. It takes everything away completely. This is the jeweled sword of the Vajra King.

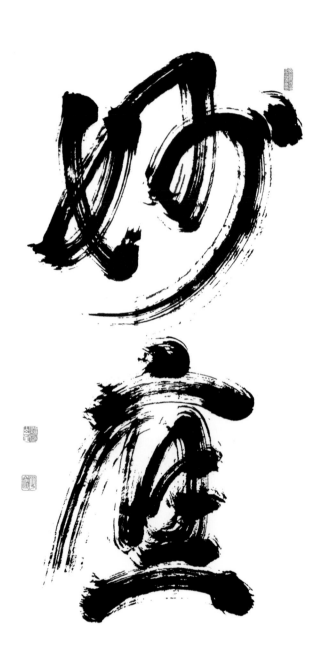

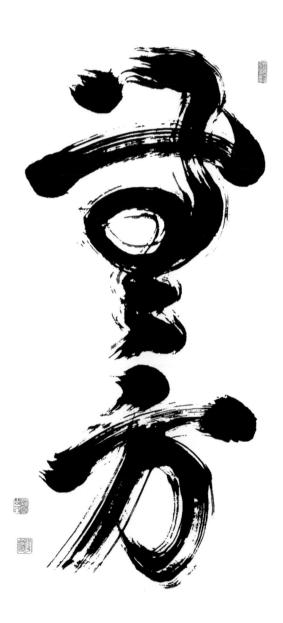

妙応 無方

Myō'ō muhō

Marvelously responding in any direction

This line is from the preface to the *Record of Rinzai*.

Just as we were when we were born, exactly as we are right now, we are all, already, a splendid grand master. We don't need to train or awaken to be endowed with this. Through our eyes, through our ears, through our mouth, through all of our feelings, this true master comes and goes continually. Going out it becomes a beautiful flower, the majestic mountains and rivers, the singing of the birds. Within, it becomes our hunger and our sleepiness, our thirst and our pain. It is boundlessly surging and can reach anywhere in the universe. This master is not some thing stuck somewhere in our physical body but an essence that comes and goes freely. We see the rivers, and it becomes the rivers; we see the mountains, and it becomes the mountains; we hear the birds' song, and it becomes that sound. We must realize this splendid person of truth, this Buddha that is in each person's body. That is all kenshō is.

"In your lump of red flesh is a true man without rank who is always going in and out of the face of every one of you. Those who have not yet proved him, look, look!" This is a sharp and thorough teaching!

With each person who came before him, Master Rinzai functioned in accordance with the other. By seeing each person clearly, Rinzai freely taught the Buddhadharma, marvelously responding in any and all directions. If we function in this way, then in each moment and on every occasion we can manifest Rinzai's marvelous responding.

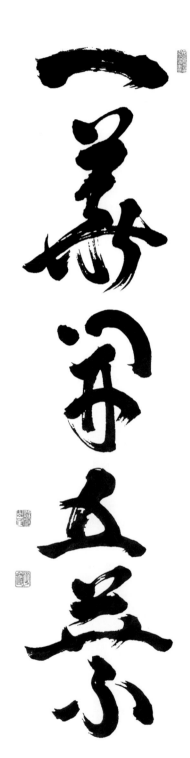

一華五葉開
結果自然成 *(overleaf)*

Ikka goyō wo hiraku
Kekka jinen to naru

A lotus flower opens five petals
And of itself bears fruit

These lines are from the poem Bodhidharma presented when giving his transmission to Niso Eka.

> I came from India, so far away, to China
> To keep the Dharma alive and to liberate all beings;
> A lotus flower opens five petals
> And of itself bears fruit.

Thus Bodhidharma passed the Dharma to Niso Eka and named him the Second Ancestor. From there the five lineages that continued the Dharma evolved naturally: the Rinzai sect, the Sōtō sect, the Igyo sect, the Hōgen sect, and the Unmon sect. Yet we must not let this division into five fool us. In Zen there is only one Truth. For this Truth to be transmitted, it must be manifested as living, breathing Dharma. Each of the Ancestors in turn, while having an individual essence, realized the exact same source as did Shakyamuni Buddha. This is how the One Awakening of the Buddha came to Bodhidharma and then flowed into these five vessels.

"A lotus flower opens five petals and of itself bears fruit" is a vow for our descendants, but we have to be peaceful in order for it to work—peaceful in our minds, in our homes, in our society, and in our country. A mind full of resentment can know the Buddha's true experience only by extinguishing the fires of greed, extinguishing the fires of ignorance, and extinguishing the fires of anger. Today all over the world people are fighting religious wars because they do not know the true source of all religions. If we realize this source, the peace of the world will be born naturally and spontaneously, because there is only one Truth.

孤來自然出家

"I came from India, so far away, to China to keep the Dharma alive and to liberate all beings." This is how Bodhidharma expressed the Truth beyond words and phrases. Niso Eka was transmitted this Truth and in turn passed it to the other Ancestors, keeping it available for the liberation of all beings.

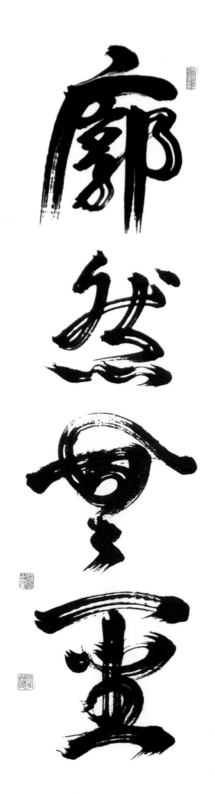

廓然無聖

When Bodhidharma reached China, the emperor welcomed him and explained that he had done everything he could to build temples, train monks, and translate sutras. He asked, "What is the merit of this?"

Bodhidharma answered, "No merit." He wasn't saying that there is anything wrong with merit but that having a mind that depends on such things is a problem.

The emperor asked further, "What is the ultimate Truth?" The emperor saw himself as a leader who truly manifested the Buddha's highest teaching.

To this Bodhidaruma replied, "Vast emptiness, nothing holy." Vast emptiness implies the huge autumn sky with not a cloud to be found. Nothing holy means that there is no division between holy and ignorant, sacred and deluded. There's only this Truth that goes beyond our physical body and state of mind.

When we think well of ourselves, we miss the great flow of the world. We have to be able to cut all of our conceptions with one slash. Then, whether in the midst of birth or death, whether giving or receiving, we are limited by nothing. Only when we know this freedom completely can we say that we have realized the Path.

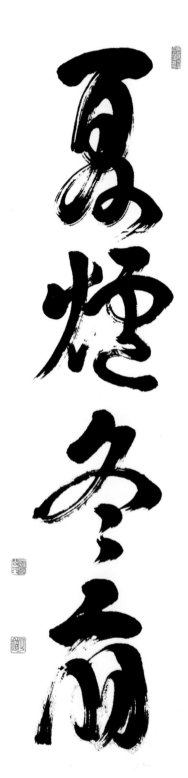

夏炉冬扇

Karo tōsen

A stove in summer, a fan in winter

In the summer, when it's hot, a fire is unnecessary. In the winter, we don't need a fan. Yet this phrase speaks of a stove in summer and a fan in winter—things we don't need, things that are extra.

In the summer a stove does not come immediately to mind, nor does the fan come out immediately in the winter. But if we are not ready ahead of time, the things we need won't be present when we do need them. Even if we don't need these things now, we can't ignore them. Because we prepare in our daily life, things are ready when we do need them. This is how our zazen is, too. In zazen, we don't need our functioning; nor do we need to sit zazen when we are functioning. When we're able to move and work, to purposely sit still isn't a priority. But our life is more than our work. The ideal is important, as is the doctrine. But most important is today's living, watching our footsteps and being right here, right now, totally present. Then our mind is always "A stove in summer, a fan in winter." In this place, in this moment, be clear in how you are. Otherwise, there is only a conceptual understanding of Zen.

We do not need a stove in summer or a fan in winter, but we give life to both when the time is right. This is where our truth resides.

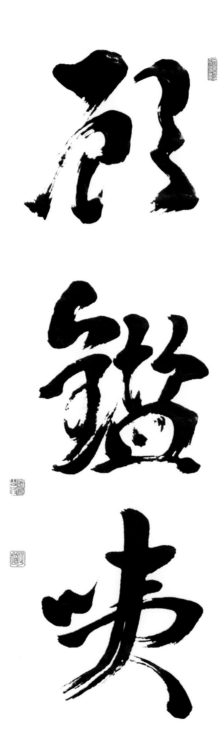

顧鑑咦

Master Unmon preferred teaching with one-character Zen expressions and often used these three: *Ko*, "Observe!" *Kan*, "Reflect!" and *I*, "That!" This became known as Unmon's "three-character Zen."

When monks came to Unmon with Dharma questions, no matter what they asked, Unmon would say, "Ko! Kan! I!" But of course his teaching was not about explicating the names of the characters themselves. Unmon would not have bothered with using words just for the sake of their meaning. Yet we can use these three expressions to see our own footsteps, to clarify our true deep Mind, and to know our own Clear Nature. Through them we may taste Unmon's infinite flavor.

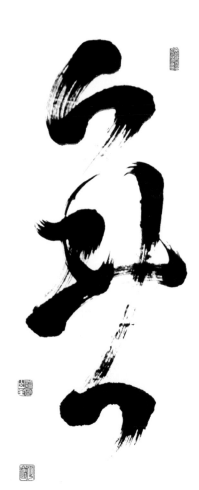

無

Mu

Once a monk asked Jōshū, "Does a dog have Buddha Nature?"

The Buddha teaches that all things—even plants, trees, and grasses—are without exception endowed with Buddha Nature. Does this hungry, greedy dog, who goes searching from garbage pail to garbage can, also have Buddha Nature? This mind that is always looking for something, wishing for something to be thankful for, and always getting caught on everything that happens, this unawakened person like me, is there really Buddha Nature there? This is what the monk was asking.

Without hesitation, Jōshū replied, "*Mu.*"

Throw your whole body and mind into that Mu as you become it. Day and night, work intently at it. Do not attempt conceptual interpretations. From morning until night and from night until morning, become a complete fool: *muuuuumuuuu*. Bring your awareness into one word, focus your attention into one point, and come to know this place where it's as if you have a burning red-hot iron ball in your throat that you can neither swallow nor spit out. Entering this place, you are aware of nothing but Mu. This is what is most important; this is samadhi. Samadhi is the central point of Buddhism, the fulcrum. To understand the truth of any religion there has to be this pure concentration.

In telling us how to do Mu, Master Mumon Ekai says to put everything else aside and look at Mu with your entire being—all of your concentration, every bit of your body and mind. If from morning until night you continue your attentive focus with no gap, then it is as it was described in the old days: from a flavorless stone, a spark will rise. But most important of all is to allow no gaps for thoughts. This is the only way it works.

Jōshū said only "Mu," but the greatest truth of the whole of the heavens and earth is manifested there. All of the roots of delusion and attachment are obliterated. This is the great Wisdom. All of our conditioned thinking forms the great doubt, and there is no person of training without this doubt. When our eyes are opened, we awaken to great faith.

And so Mumon Ekai says in his poem:

The dog! Buddha Nature!
The Truth is manifested in full!
A moment of yes and no
Lost are your body and soul!

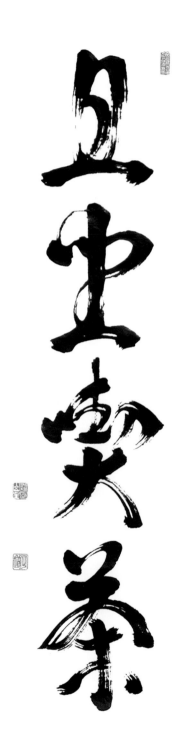

且坐喫茶

Shaza kissa
Sit down and have some tea

Sit down and have some tea! See for yourself how easily you can return to a centered state of being. But just putting your legs out in front of you isn't enough. In Japan we put a cushion on the floor and sit on that cushion to drink our tea. Sitting in this way will have the effect of bringing you back to your physical and psychological center.

Most of the statues of the Buddha show him sitting, because Buddhism is born from sitting. Sitting allows you first to align your body and then to align your mind. Then, in accordance with that aligned mind, you align your external world, your neighborhood, your country, your society, your entire world. This aligning of everything happens more and more as you sit, affecting all of your functioning and actions.

First, sit and be settled, even if it's only for a short time. The stability of your mind is what is most important. Today people are running around far too much. We don't even have to sit *for* something. We can sit here just for the sitting.

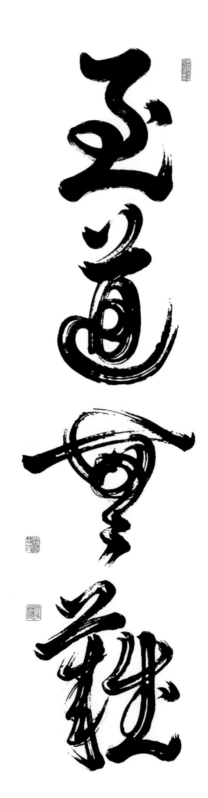

至道無難

Shidō bunan

The Great Way is without difficulty

These words are found in Sanso Kanchi's *Affirming Faith in Mind*, a guide to practice that is kept close at hand by all monks and practitioners.

What is it we have to awaken to? This is the question. What are you? Who am I? What is alive here? In the way of Zen, satori or kenshō is not something to be sought somewhere far away; it's that Mind within each of us. To see this is enlightenment; enlightenment, just as it is, is the believing mind. There is no kenshō without believing, and no true believing without the experience of kenshō.

Where do we take refuge in our everyday life? Each day, all day long, we sit and stand and walk and eat and work. The way in which we live and move, the expression of that essence with nothing wasted, is the Path; this is Buddha Nature. Believing in Mind is to know that this Buddha Nature is in all things; that is what is most important.

To follow the Great Way we don't imitate someone else but fill the heavens and earth with our own confidence. That which arises from that true Mind we had at birth, that Mind as clear as an autumn sky, is always virtuous. That purity comes from knowing the clear Mind that is the Great Way without difficulties. What is Truth? What is our Original Nature? Our own deep root is the true Path for us to follow.

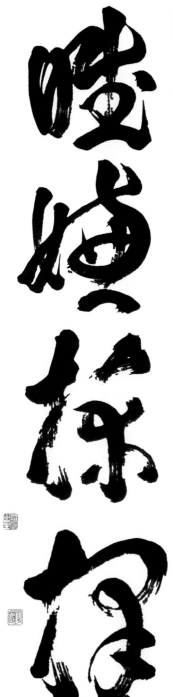

唯嫌揀擇

Tada kenjaku o kirau
Just avoid picking and choosing

The Path of the Buddha is said to be an awareness beyond words and phrases. First we encounter and understand something, then we learn it with our body, and then we practice it until it becomes second nature. No matter how well we've understood something with our heads, it must also be practiced and learned with our whole being. Art, music, or sports have to be directly experienced not only with the head but with the whole body. Only when we make the experience our own do we come to a deeper understanding. When we practice anything in this way it becomes a living Zen.

When we have a preference we want something to be this or that way, instead of responding to what is in front of us. When we fall into such a narrow perspective we are no longer on the Great Way. This is why it's said that the Great Way is without difficulty, as long as we can avoid picking and choosing.

We have to know that huge abundant state of mind where no self-conscious awareness exists. What is most important is that an action comes forth from a bright and magnanimous Mind, one with no trace of a cloud anywhere. Our best refuge is to hold on to nothing at all. When things are finished, we let go of them immediately. We do not fret over things that have not yet happened. We live in a bright clear state of mind and grasp the real world from that state of mind. Then there is no difficulty on the Great Way.

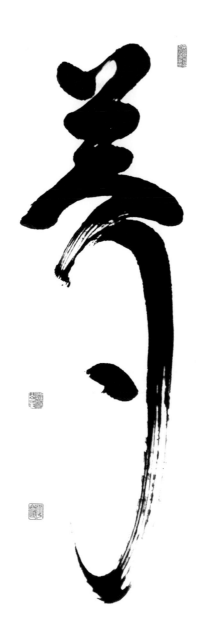

夢

Yume
Dream

In life we have dreams, we have hopes, we have ideals. But what does it mean to have a dream? Everything in this world is in flux. No matter how real we may think things are, everything passes. We all think our life is special, but no matter how happy we are or how much we achieve, we all die.

We live in a dream, in delusion. We can see the beautiful flowers and hear the birds' lovely songs, but we don't see what is alive inside that experience. We see a superficial layer of the world and acknowledge that as important. We don't see that it's all transient, a dream of a dream. Instead of realizing that we are living a dream, we take the superficial to be real and permanent. But in Buddhism we recognize it all as a dream and awaken to what is real.

It is not bad to have a dream. Because we dream, we can achieve things. But have humans become any better for all the things that have been discovered and created? Have our values improved? Is the world any more at peace? We chase dreams, but we forget to realize ourselves. We have to see the reality and value of who is alive right here and now. When we awaken to the splendid value of each person, we no longer need to depend on dreams and hopes and ideals. Instead, we can depend on our own life right at our very own feet.

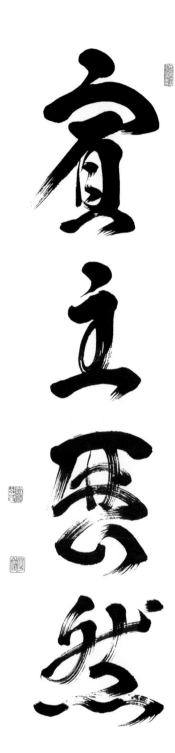

賓主歴然

Hinju rekinen

Guest and host are clearly distinguished

These are among the best-known words of Master Rinzai, who taught of "the four positions" of host and guest. At times there is a person and no world; at times there is no person and a world; at times there is no person and no world; and at times there is both a person and a world. The four positions express the subtleties of how the host and the guest engage. In our everyday life, how is this mind expressed in an awakened way?

One day the head monks of the east zendō and the west zendō met and both gave great shouts. One of the monks who saw this went to Rinzai and asked, "So which is the host and which is the guest?"

If it didn't matter who is host and who is guest, the world would be very confused. Sometimes we invite guests over and provide for them, and sometimes we visit others. When we converse we listen to what others say, and sometimes we offer our own opinion. Rinzai emphasized the importance of this free functioning. So when the monk asked him which head monk was host and which was guest, he replied, "This is obvious. If you don't understand, ask the two monks themselves."

Was your shout that of a host or that of a guest? Only the people involved can know this. Bringing forth joy from the guests is the host's work. The guests honor the host by appreciating what is offered to them. Then, while they may appear as guests in making efforts to honor the host, they also become the master. This is the absolute master and the absolute guest. This absolute master fills the whole universe until we do not even know that we are the master.

When we awaken to this absolute master, we become one with everything. In realizing this most basic truth, we're able to be accepting in every situation.

Glossary

Affirming Faith in Mind. See Sanso Kanchi.

Ancestors. In the Zen tradition an ancestor is one who has thoroughly awakened to the Buddha Mind and who transmits it to succeeding generations through deep realization and correct understanding. According to the Zen literature, the first Zen ancestor, Makakashō, received transmission from the Buddha in the following way. One day on Vulture Peak the Buddha, instead of giving his usual sermon, simply held up a flower. No one responded except Makakashō, who broke out in a smile. The Buddha then said to Makakashō, "I have the True Dharma Eye, the Marvelous Mind of Nirvana, the True Form of the Formless, and the Subtle Dharma Gate, independent of words and transmitted beyond doctrine. This I entrust to you, Makakashō."

Ba Bo (Ma Fang). Nothing is known of Ba Bo other than that he was a Sung dynasty court official and the author of a preface for the *Record of Rinzai.*

Banzan Hōshaku (P'an-shan Pao-chi; 720–804). A Dharma successor to Baso Dōitsu.

Baso Dōitsu (Ma-tsu Tao-I; 709–788). The teacher of Nansen Fugan and Hyakujō Ekai, among others, Baso is considered one of the most important of the Chinese Zen masters, originating teaching methods, such as sudden shouts, that have become characteristic of Zen.

Blue Cliff Record (*Hekiganroku*). A central koan text in the Rinzai tradition, published in 1128. The *Hekiganroku* originated in a series of lectures by Engo Kokugon (1060–1135) on the *Secchō hyakusoku juko*, a collection of one hundred koans with commentary verses by Setchō Jōken (980–1052). The name *Hekiganroku* derives from a calligraphy of the characters *heki* (blue) and *gan* (cliff) that hung in Engo's room.

Bodhidharma (d. 532). The twenty-eighth ancestor of Indian Zen and the first ancestor of Chinese Zen. Bodhidharma is commonly referred to as Daruma in Japan.

Bodhisattva Vow. The bodhisattva vow can be summarized as, "To attain enlightenment and liberate all sentient beings." That is, we awaken to the wisdom of the Pure Mind that each and every one of us is endowed with from birth, then take that wisdom into society to relieve the suffering of others. Although it is not possible to know the full light of wisdom without enlightenment, compassion is possible in this very moment. The desire to do whatever one can to relieve the suffering of other people can be acted upon at any time. To think always of society and offer ourselves completely is our responsibility as humans and an expression of the very essence of our being. By acting in accordance with this we move beyond our

limitations and clarify our minds with the wisdom that arises through functioning. Without this there can be no true liberation of all beings.

Butchō. The Zen master with whom the haiku poet Matsuo Bashō studied.

Buddha (Fifth century B.C.E.). In the northeast area of India, in what is today Nepal, the Buddha was born as Gautama Siddhartha, the heir to the throne of the Shakya clan. Later he also came to be known as Shakyamuni, "the sage of the Shakyas." Gautama Siddhartha renounced everything in order to understand life's deepest meaning and the source of pain and suffering, and to find the Path to true joy for all humankind. He started his search with six years of ascetic training. When this failed to bring him the resolution he was searching for he turned to the Path of meditation. At Bodhgaya he sat silently under the bodhi tree until, upon seeing the radiance of the morning star, he realized the Clear Mind that is one with the material world of form. After this experience he went out into the world to teach, continuing his efforts to liberate people until he passed away at the age of eighty. The historical person who lived twenty-five hundred years ago was the first to realize this Truth and how to teach it, and this same Truth has been passed down to us by the Ancestors and continues to liberate people today.

Buddhadharma. See Dharma.

Buddha Nature. "Buddha Nature" is a provisional name for the ineffable pure Mind with which all beings are endowed since birth, and the full realization of which leads to the attainment of buddhahood.

Chōsha Keijin (Ch'ang-sha Ching-ts'en; d. 868). Chōsha was a disciple of Nansen Fugan, who was in turn a disciple of Baso Dōitsu.

Cold Mountain Poems. See Kanzan.

Comprehensive Record of the Lamp (*Katai Futōroku*; Chia-t'ai p'u-teng lu; 1204). Compiled by a monk of the Ummon school, the *Comprehensive Record of the Lamp* provides a detailed account of Zen during the Sung period in China.

Confucius (K'ung-fu-tzu; 551–479 B.C.E.). The celebrated Chinese sage who expounded the system of thought and ethics that came to be known as *Confucianism*. His *Analects* present the core of his teaching.

Daruma. See Bodhidharma.

Daitō Kokushi (1282–1338). The posthumous title (literally, "National Teacher Daitō") given to the Japanese Zen master Shūhō Myōchō, the founder of Daitoku-ji and the predecessor of all Japanese Rinzai Zen masters today.

Dhammapada. A collection of 423 verses regarded as the most succinct expression of the Buddha's teachings.

Dharma. The universal laws of the mind to which the Buddha was awakened; the laws that govern the existence of each and every person. Dharma also refers to the unifying, undifferentiated Mind without form or substance that extends throughout the universe and embraces everything without exception. This is what Rinzai speaks of when he says, "The True Mind has no form and extends in all ten directions." All people, when they encounter this true source, experience the same essence.

Dōgen Zenji (1200–1253). Japanese Zen master who brought the traditions of the Sōtō school from China to Japan. His *Shōbōgenzō* is considered one of the most profound writings of Japanese Zen.

Dōjō. A Zen monastery; a place to clarify the Buddha Nature. Most commonly, the word *dōjō* refers refers to a place where one can, under the guidance of a teacher, dig deep within and clarify the essence of Zen. A dōjō is not necessarily a formal location, but can be anyplace one strives to clarify this essence. All people of training can work to clarify this essence wherever they are; it does not require a prescribed system or building. Traditionally it is said that three people and a true teacher supporting and polishing each other form a dōjō.

Enlightenment. See Kenshō.

Entangling Vines (*Shūmon Kattōshū*). A Japanese Rinzai koan collection compiled in the late seventeenth century and published in 1689, the *Shūmon Kattōshū* consists of 282 cases. The phrase "entangling vines" is a synonym for "koans."

Flower Garland Sutra (Avatamsaka Sutra). One of the most influential of the Mahayana sutras, the Avatamsaka Sutra is considered to be the Buddha's exposition on the ultimate nature of Truth. It describes all existence as a manifestation of the Dharma in which all things are interrelated and interpenetrating.

Genyō Zenshin (Yen-yang Shan-hsin; 850–920). One of Jōshū's Dharma heirs.

Gisan Zenrai (d. 1877). A master at Sogen-ji known for his great virtue and the large number of disciples who came to train with him. He also trained at Sogen-ji, receiving Dharma transmission from Taigen Shigen (1768–1837).

Goso Gunin (Hung-jen; 601–674). The fifth ancestor of Chinese Zen.

Hakuin Ekaku (1686–1769). Japanese Zen Master who is credited with revitalizing the Rinzai school of Zen. His *Song of Zazen* and other works were written in the common language of the time, rather than in the Sino-Japanese that only the upper classes could read.

Haryō Kōkan (Pa-ling Hao-chien; n.d.). A Dharma successor to Unmon Bunne, Haryō, like his teacher, was known for the subtle flavor of his words.

Heart Sutra (Hanna Haramita Shingyō). This heart of the Prajna Paramita Sutra is frequently recited in Zen temples. In abbreviated form it serves as a mantra.

Hōgen Bun'eki (Fa-yen Wen-i; 885–958). Because he was the abbot of the Seiryō temple in Nankin, the founder of the Hōgen line of Zen Buddhism is also known as Master Seiryō. Hōgen is said to have responded to questions with answers so true that they functioned like one arrow meeting another point-to-point in midair. The spirit of the Hōgen line is that of a hen and its chick pecking from without and tapping from within during the hatching of an egg. In this way, the master and disciple work together in arriving at satori.

Hyakujō Ekai (Pai-chang Huai-hai; 720–814). Hyakujō originated the formal system of training used in Zen monasteries today. His words "A day without work is a day without food" reflect his humble and practical mind and deep integrity.

Jō Hōshi (Seng-chao; 382–414). Jō Hōshi was one of the four great translators who were disciples of Kumarajiva. He also wrote several excellent treatises that address the heart of Zen, such as those on the Prajna Sutras.

Jōshū Jūshin (Chao-chou Ts'ung-shen; 778–897). Jōshu, who received transmission from Nansen, is said to have started teaching only after the age of eighty. His "Mu" is the best known of all Zen koans, but many other koans express his teachings.

Kaian Kokugo (*Dream Words from the Land of Dreams*). Zen commentaries by Hakuin on the teachings of Daitō Kokushi.

Kanzan (Han-shan; n.d.). Little is known about the life of this hermit-poet, who is said to have left his works written on rocks, trees, and the sides of buildings. Of the six hundred poems he is thought to have written, around three hundred survive and are collected in the work known as the Cold Mountain poems.

Karma. According to the principle of *karma*, all deliberate acts inevitably result in certain consequences for the one who performs them, according to the intention behind the act. Karma, being based on universal law, applies to all beings.

Kendō (way of the sword). Japanese style fencing.

Kenshō. Enlightenment; the awakening to one's True Nature, prior to ego. Ego is like the transient waves on the water's surface; one's Buddha Nature is the entire body of water. To awaken to this true original quality of the mind is to experience kenshō.

Kidō Chigu (Hsü-t'ang Chih-yu; 1185–1269). A great Chinese Zen master whose lineage, through his Japanese student Nampo Jōmyō (1235–1309), includes all Rinzai masters in Japan today. Kidō left many important koans still used in Rinzai Zen. Hakuin's commentary on Kidō's teachings has been published as *Essential Teachings of Zen Master Hakuin*.

Koan. Specific words and experiences of the ancients that cannot be solved by logic or rational thought. They are used in Zen to cut dualistic thinking, precipitate awakening to Buddha Nature, and rid oneself of ego. The word *koan* originally referred to a legal case that established a precedent. In Zen, however, a koan is not a case that deals with past and future, good and bad; rather, it allows us to clarify the truth by cutting through all of these concepts. If we cannot pass through the Ancestors' gates, our Path will be obstructed by dualistic concepts; we will be nothing more than a blown weed caught by words describing someone else's experience.

Kyōgen Chikan (Hsiang-yen Chih-hsien; d. 898). Kyōgen is perhaps best remembered for the story of his enlightenment upon hearing the sound of a piece of tile hitting bamboo.

Kyūsei Dūfu (Ching-ch'ing Tao-fu; 868–937). A Chinese Zen master who succeeded Seppō Gison (822–908). He took his name from the temple where he later taught, Kyōsei-ji.

Lotus Sutra. Said to date from the first century, the Lotus Sutra has had a wide influence in Mahayana Buddhism. Its principal teaching is that of the Buddha Vehicle (the One True Vehicle), which supersedes all expedients and brings all beings to buddhahood.

Mahayana Buddhism. Mayahana ("Great Vehicle") Buddhism is one of the main branches of Buddhism, along with Theravada and Vajrayana. It is the Great Vehicle in which all people can ride to liberation, and through which everyone can offer efforts to liberate other beings. It exists within our deepest mind, the same Clear Mind as the Buddha. Vowing to liberate all people in society from delusion and suffering, we clarify our own mind and work to help others. The Mahayana is not just for a handful of ordained people. To have a job and family,

with all their problems and confusions, yet to be realized and liberated as a layperson is the way of the Mahayana today.

Makakashō Sonja (Mahākāshyapa). One of the principal disciples of the Buddha and, according to the Zen tradition, the First Ancestor of Indian Zen.

Matsuo Bashō (1644–1694). The most famous poet of the Edo period in Japan, Bashō is known for his haiku.

Mu. For realizing the mind that holds on to nothing whatsoever, many monks have used Jōshū's "Mu" koan. Focusing on it while standing, sitting, walking, they have taken their scattered thoughts and consciousness and gathered them into one. To do Mu is to burn everything in the furnace of Mu. No matter what we do or who we encounter, we gather it all together and throw it all into Mu.

Mumon Ekai (Wu-men Hui-k'ai; 1183–1260). Considered one of the leading Chinese Rinzai masters of his time, Mumon is today remembered primarily for his compilation of the famous koan collection the *Mumonkan.*

Mumonkan. A collection of forty-eight koans compiled by Mumon Ekai. The title is often translated in English as *The Gateless Gate.*

Nansen Fugen (Nan-ch'uan P'u-yuan; 748–835). Nansen was a Dharma successor of Baso Dōitsu. He was a brother disciple of Hyakujō and the teacher of Jōshū.

Nirvana. The state of having extinguished the flames of greed, ignorance, and anger.

Niso Eka (Hui'ko; 487–593). The second Chinese Ancestor of Zen after Bodhidharma.

Ōbaku Kiun (Huang-po Hsi-yun; d. 850). A student and Dharma successor of Hyakujō, Ōbaku himself had thirteen Dharma successors, including Rinzai.

Original Nature. The original mind-ground with which everyone is endowed, and which unifies all beings at all times.

Ōsesshin. An intense practice intended to clarify one's True Nature, ōsesshin consists of one week of continuous zazen with breaks only for sutra chanting, eating, and sleeping.

Pang, Layman (P'ang Yün; 740–808). Along with Vimalakirti, Pang is one of the most famous householders in the Zen literature, known through his poetry and the records of his conversations about Zen. Layman Pang did sanzen first with Sekitō Kisen (Shih-t'ou Hsi-ch'ien; 700–790) and then with Sekitō's successor Yakusan Igen (Wueh-sahan Wei-yen; 745–828), before studying with Baso Dōitsu, from whom he received transmission.

Prajna wisdom. The deep wisdom of the life energy that is alive right here and now, beyond what can be conveyed in intellectual terms. Prajna wisdom radiates everywhere, through the three realms vertically and throughout the ten directions horizontally. It forgets the body and becomes one with each moment, beyond an objective self and objective other, where that which is shining and that which perceives the shining are one.

Rinzai Gigen (Lin-chi I-hsüan; d. 867). The founder of the Rinzai school and a Dharma successor of Ōbaku Kiun, Rinzai was in the eleventh generation after Bodhidharma. He guided his students in a way that was penetrating and powerful, like a general urging on his troops. His *Rinzai-roku,* or *Record of Rinzai,* clearly shows the meticulousness of his teaching, as well as the freedom and expansiveness of his way.

Rōhatsu Ōsesshin. The most intense one-week sesshin of the year, in which Zen practicers make a determined effort to realize kenshō. *Rō* is a Japanese word for December, and *hatsu* is the Japanese word for eighth. It was on the eighth of December that the Buddha is said to have seen the morning star and awakened to his True Nature. From ancient times this has been considered the sesshin in which one must lose one's life completely; only after doing this sesshin is one considered to be a true person of Zen training. It is impossible to count how many have realized their True Nature through the opportunity of the Rōhatsu ōsesshin.

Rokuso Enō. See Sixth Ancestor.

Ryōkan Daigu (1758–1831). A Japanese Zen master who preferred to live as a hermit, Ryōkan wrote poems that are considered among the most beautiful expressions of Zen in Japanese literature.

Samadhi. A state of concentration, in the deepest forms of which one can become one with time, place, and surroundings; the term can also refer to more active states of uniting with what one is doing.

Sanso Kanchi (Sosan; Seng-ts'an; d. 606). The Dharma successor to Niso Eka and thus the third Chinese ancestor after Bodhidharma. His *Affirming Faith in Mind* (*Shinjinmei; Hsin-hsin Ming*) is one of the earliest Zen texts.

Sanzen. The process of working with a true teacher in order to remove one's ego attachments and realize the state of mind of the Buddha and the Ancestors. Sanzen is also called the great furnace or the great anvil, since our realization of Buddha Nature has to be repeatedly forged and purified in the hot fire of the master-disciple relationship. Sanzen is not a process of intellectual discussion or psychological analysis. To rid the mind of impurities we must work continually until our clear Original Mind is realized.

Satori. The Japanese term for the experience of enlightenment. The terms kenshō and satori have almost exactly the same meaning and are often used interchangeably. See Kenshō.

Setchō Jūken (Hsüeh-tou Ch'ung-hsien; 980–1052). The compiler of the one hundred koans that form the basis of the *Blue Cliff Record*. Setchō was one of the last great masters of the Unmon school.

Sixth Ancestor (638–713). The title of Rokuso Enō (Hui-neng), the sixth Zen Ancestor and final holder of the Chinese Zen patriarchate. Enō was enlightened in his youth upon hearing a passage from the Diamond Sutra. He later studied under Gunin, the Fifth Ancestor, and was recognized as his successor. He spent the last thirty-five years of his life teaching at Hōrin-ji in southern China. With Enō, Zen is considered to have taken on its distinctly Chinese character.

Shishin Goshin (Ssu-hsin Wu-hsin; 1043–1114). Shishin was a successor of Maidō Soshin (1025–1100); his enlightenment is said to have occurred on pilgrimage when he heard a clap of thunder.

Shōtoku Taishi (572–621). A regent and politician of the Asuka period in Japan, Shōtoku was an avid follower of the teachings of the Buddha.

Sōgen. The source (*gen*) of the Sixth Ancestor's Dharma teachings at the temple Sōkei (*sō*).

Sogen-ji. The Rinzai Zen temple in Okayama, Japan, where Shodo Harada has taught since 1982.

"Song of Enlightenment." See Yōka Genkaku.

Sutra. The Buddhist teachings are traditionally divided into three parts: precepts, sutras, and doctrine. The precepts provide rules for living in accordance with the essence of awareness. The doctrine analyzes and explains the essence of enlightenment. The sutras are the sermons and discourses said to have been delivered by the Buddha himself. The sutras thus express the essence of the Buddha's enlightenment, and are not simply words about it. In that sense they cannot be interpreted, nor can anything be added to them or taken away.

Taizui Hōshin (Ta-sui Fa-chen; ninth century). A master in the lineage of Hyakujō Ekai.

Takuan (1573–1645). The name adopted by the Japanese Zen master Sōhō, who was also known as a poet, calligrapher, tea master, and gardener. His letter to the swordsman Yugyu Menenori on the spirit of swordsmanship has been translated into English as *The Unfettered Mind.*

Tang Dynasty (618–907). Considered by historians to be a high point of Chinese culture. The influence of Buddhism is evident in the poetry and art from the period.

Tekisui Giboku (1822–1899). After training under Gisan Zenrai at Sogen-ji, Tekisui played an important role in the revival of Buddhism in Japan after the religious persecutions of the Meiji period.

Tendai Tokushō (T'ian-tai Te-shao; 891–972). The second Ancestor in the Zen line of Hōgen Buneki.

Ten directions. North, south, east, west, the four directions in between, up, and down.

Ten thousand things. This term refers not to a precise number but to the infinite variety of things in the phenomenal world.

Three worlds. The world of desire, the world of form, and the formless world.

Tokusan Senkan (Te-shan Hsuan-chien; 781–867). Tokusan was a scholar monk who became dissatisfied with study when he realized it would never lead to an understanding of the Original Mind. He practiced Zen under the master Ryōtan Sōshin (Lung-t'an Ch'ung-hsin; n.d.). After succeeding to Ryōtan's Dharma he became known for his use of the stick and his saying "Thirty blows if you speak; thirty blows if you don't." Tokusan had nine Dharma successors, including Seppō Gisan (Hsueh-feng I-ts'un; 822–908) and Gantō Zenkatsu (Yen-t'ou Ch'uahn-huo; 828–887).

Tōzan Ryōkai (Tung-shan Liang-chieh; 807–869). A successor of the master Ungan Donjō (Yun-yen T'an-sheng; 782–841) who, together with his disciple Sōzan Honjaku (Ts'ao-shan Pen-chi; 840–901), is considered cofounder of the Sōtō sect in China.

Transmission of the Lamp (Ching-te Ch'uan Teng-lu; 1004). A compilation of biographies of more than six hundred prominent Buddhist masters produced in the Song dynasty by the Chinese monk Dōsen (Tao-hsüan). The work was published in thirty volumes and is the primary source of information on the history of Zen Buddhism in China. Many of the koans found in later compilations appeared in print here for the first time.

Unmon Bunne (Yun-men Wen-yen; 864–949). Unmon is known for his use of short, often one-word, responses to questions. These came to be known as Unmon's "one-word barriers." He raised many great masters, including Tōzan Shusho. Setchō Jōken, who was also of the Unmon line, preserved many of Unmon's words in the *Blue Cliff Record*.

Vimalakirti Sutra. Centering on the teachings of the layman Vimalakirti, the Vimalakirti Sutra expresses the Mahayana ideal that awakening is available to everyone.

Vulture Peak (Griddhraj Parvat). A small mountain just outside the Indian city of Rajgir where the Buddha expounded many of his teachings.

Yōka Genkaku (Yung-chia Hsuan-chueh; 665–713). The author of the "Song of Enlightenment" and a Dharma successor of the Sixth Ancestor.

Zazen. Seated meditation in which one cuts all connections with the external world and lets go of all concerns within.

Zendō. The meditation hall in which monks live and practice zazen.

Index of Calligraphies (English)

Index of Calligraphies (Romaji)

Shodo Harada Roshi is a highly respected Zen teacher and world-class calligrapher, whose students include many American and international Zen teachers. He is the disciple and Dharma heir of Yamada Mumon Roshi, also a renowned Zen master and Zen calligrapher. In this lineage, calligraphies such as the ones in this book are used as one of several powerful means through which to teach the Dharma. Harada Roshi is the abbot of Sogen-ji Zen Monastery in Okayama, Japan, with plans to take up residence in Whidbey Island, Washington, amid his American Zen community.

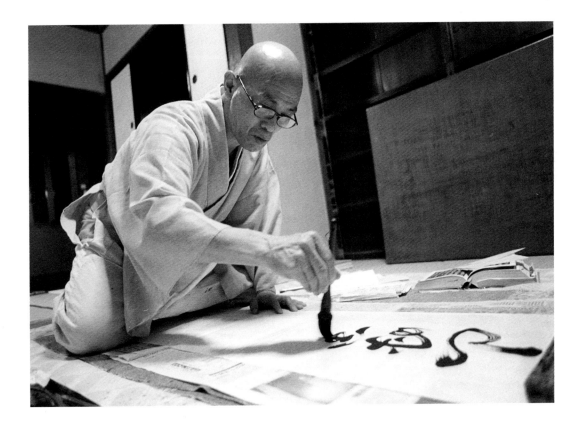

About Wisdom Publications

Wisdom Publications, a nonprofit publisher, is dedicated to making available authentic works relating to Buddhism for the benefit of all. We publish books by ancient and modern masters in all traditions of Buddhism, translations of important texts, and original scholarship. Additionally, we offer books that explore East-West themes unfolding as traditional Buddhism encounters our modern culture in all its aspects. Our titles are published with the appreciation of Buddhism as a living philosophy, and with the special commitment to preserve and transmit important works from Buddhism's many traditions.

To learn more about Wisdom, or to browse books online, visit our website at www.wisdompubs.org.

You may request a copy of our catalog online or by writing to this address:

Wisdom Publications
199 Elm Street
Somerville, Massachusetts 02144 USA
Telephone: 617-776-7416
Fax: 617-776-7841
Email: info@wisdompubs.org
www.wisdompubs.org

THE WISDOM TRUST

As a nonprofit publisher, Wisdom is dedicated to the publication of Dharma books for the benefit of all sentient beings and dependent upon the kindness and generosity of sponsors in order to do so. If you would like to make a donation to Wisdom, you may do so through our website or our Somerville office. If you would like to help sponsor the publication of a book, please write or email us at the address above.

Thank you.

Wisdom is a nonprofit, charitable 501(c)(3) organization affiliated with the Foundation for the Preservation of the Mahayana Tradition (FPMT).